CATALOGUE OF
THE ENGRAVED PORTRAITS
BY
JEAN MORIN

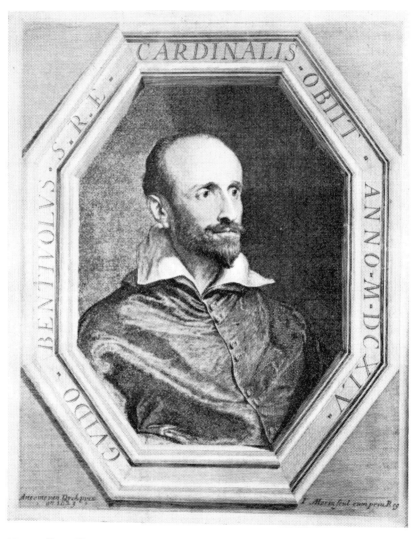

No. 5, State II, a CARDINAL BENTIVOGLIO

CATALOGUE

OF THE

ENGRAVED PORTRAITS BY
JEAN MORIN
(c. 1590—1650)

BY

MURRAY HORNIBROOK

AND

CHARLES PETITJEAN

CAMBRIDGE
AT THE UNIVERSITY PRESS
1945

CAMBRIDGE
UNIVERSITY PRESS

University Printing House, Cambridge CB2 8BS, United Kingdom

Cambridge University Press is part of the University of Cambridge.

It furthers the University's mission by disseminating knowledge in the pursuit of education, learning and research at the highest international levels of excellence.

www.cambridge.org
Information on this title: www.cambridge.org/9781107492431

© Cambridge University Press 1945

First published 1945
First paperback edition 2015

A catalogue record for this publication is available from the British Library

ISBN 978-1-107-49243-1 Paperback

CONTENTS

Available for download from www.cambridge.org/9781107492431

ILLUSTRATIONS

PREFACE

My uncle by marriage, Charles Petitjean, to whose pen, in collaboration with Charles Wickert, we owe the standard work on Nanteuil, commenced the collection of the material for this work on Morin more than forty years ago, but as the work on Nanteuil was already in an advanced stage at that time, this lesser work was laid aside until twenty years later, when the publication of the work on Nanteuil almost coincided with the failure of Petitjean's health and his consequent inability to continue the work on Morin and, most regretfully, since he preferred the engravings of Morin to those of all other French Masters, he had to hand it over to me for completion. This, as I had been assisting him in the collection of the material, I was best qualified to do and, since his death, I have continued the search for differences in states, and the task has proved exceptionally difficult inasmuch as there are so few complete collections, outside the very fine one in Paris; and some portraits are so rare in any state that it has been a question, not so much of searching museum and other public collections, but of trying to get in touch with small collections, or even the owners of single impressions, for comparison. These difficulties, one imagines, must have weighed heavily with Robert-Dumesnil, whose work in *Le Peintre-Graveur Français* has hitherto been the standard on this Master, since so very much of interest that we have found escaped his notice; to the portrait of Jansénius, for instance, he ascribes but two states, whereas there are six.

The discovery that Morin used watermarked papers for his states in some sort of arithmetical progression is entirely due to Petitjean, and is a matter of the greatest interest, which may also be found to have a bearing on the use of watermarked papers by other engravers.

I desire, on behalf of Charles Petitjean and myself, to express our thanks to the curators of museums and owners of collections, large

and small, who allowed us to use their impressions for comparison, and to the large number of owners of single impressions of interest who forwarded them, often from very long distances, by post for our examination; and especially would I like to put on record our thanks for the assistance ungrudgingly rendered to us for many years by the late John Charrington, Hon. Keeper of the Prints at Cambridge, who kept us in touch with most of the impressions passing through the hands of British printsellers or offered in the sale rooms.

MURRAY HORNIBROOK

1944

BENTIVOGLIO (p. 16). When the text of this book was already in final proof two impressions of this plate came to light, both obviously of a later state than the two hitherto known. A description of this state is added here:

III. Except for faint traces on the lower edge of the border, this scratched line has been erased by a burnisher, by which process the parallel lines, through which it passed, were also effaced; those above the base of the letter 'I' have been remade rather thickly, the second and third lines from the base sloping up so that they no longer coincide with their continuations through 'I'. The burnisher has also effaced some of the parallel lines on the high light of the ridge of the border, leaving a clear oval space about 10 mm. by 4 mm. Thick papers, with no watermark, or with a single watermark in the centre of the sheet. (Mr M. Hornibrook, and probably others.)

JEAN MORIN

Curiously little is known about the life of this great French Master, who was born in Paris *circa* 1590 and died about 1650. Commencing as a painter he soon turned his attention to engraving, to which he devoted his unusual talents. He was son-in-law to Philippe de Champaigne and found, in the portraits painted by his father-in-law, a perfect outlet for his genius; possibly no other engraver has enabled us to realize, in black and white, the tints of the flesh and the colours of the costumes of his subjects. The position of his father-in-law as a Court Painter gave Morin a choice of subjects which included most of the people of importance of his day, and Champaigne found in Morin the engraver best suited to translate his paintings into black and white—it was a perfect partnership and, as a result, we have handed down to us about fifty portraits of supreme interest, both artistically and historically.

Morin's work was executed in a mixture of etching and stippling, and to many connoisseurs, especially in France, his work is appreciated above that of any other contemporary Master; nevertheless, to very many print lovers it is curiously little known, and I was, at first, sometimes surprised at the lack of knowledge of his work by otherwise well-informed collectors until I realized that the number of impressions of his portraits in circulation is comparatively very small, and while there are about a dozen of his portraits, mostly the least interesting, like those of the brothers de Thou, that are met with fairly frequently in sales of Old Master engravings, impressions of many others are so rare, in any state, that they are almost unknown; but few people who have seen the earlier impressions of such portraits as those of Richelieu, Mazarin and Cardinal Bentivoglio, for instance, would not wish to possess them; unfortunately they are extremely rare. Almost equally interesting are the portraits of de Retz, Andilly, Tubœuf, Vignerod, de Netz and the charming Marguerite Lemon.

In addition to those already mentioned, any impressions of de Valois, de Gevres and de Sales are rare, and of Conti, Louis XI and the two of Verger d'Hauranne, extremely rare; in fact the second portrait of Verger is so scarce that the late John Charrington, whose very fine collection of Morins was among his gifts to the Fitzwilliam

Museum at Cambridge, was trying for nearly fifty years to obtain an impression of it, although he had correspondents in most parts of the world; and I came across only two impressions for sale, both of which I bought and, by great good fortune, one of them proved to be the first state of which, as far as is known, the impression in the Bibliothèque Nationale in Paris is the only other.

After the description of a state, in the text, the addition of the words in brackets: (Paris, etc.), indicates that this state is not unusually rare. In the case of states of which only a very few impressions are known, the names of the collections, public or private, containing them are given.

A word on Morin's technique. The etched lines on a wax surface being bitten into the plate by acid, somewhat pear-shaped depressions are made on the plate, the narrow end being uppermost. Line engraving, on the other hand, makes a 'V'-shaped impression on the plate and, in comparing Morin's work with that of contemporary line-engravers, one must realize that the two different methods give two entirely different types of printed impressions. The early line impressions are 'brilliant' while the lines are sharp, but become dull with the use of the plate. The very early Morins, however, are never 'brilliant', but have a wonderfully soft silvery tone that once seen can never be forgotten. With the use of the plate and consequent widening of the neck of the 'pear', the impressions commence to lose their definition and, on being re-worked, the new impressions are 'brilliant' but hard, with violent contrasts owing to the accentuation of the blacks; 'brilliant impressions', in the case of Morin's portraits, should therefore always be regarded with suspicion, as it is practically certain that they will be found to be late states.

WATERMARKS

As regards the order in which Petitjean placed the watermarks, we can definitely state that we have never met with an impression bearing the watermarks 1 & 1 which has not proved to be the very earliest of that portrait. In cases where there is no impression bearing the watermarks 1 & 1 the earliest state has been, almost invariably, 0 & 2, but, exceptionally, in two cases, those of Omer Talon and J. A. de Thou, where the first state has watermarks 3 & 4, impressions of their second state have been met with 0 & 2, and in the case

of the first portrait of Cardinal Borromeo, while the first state has 0 & 2 and the second state 3 & 4, odd impressions of the first state have been met with watermarks 5 & 6.

My own opinion about these few exceptions is that they are due, in all probability, to the errors made by pupils and were not intentional. Engravers left a good deal of the spade work to their pupils and Morin seems to have suffered from some particularly careless ones. In several cases, specially mentioned in the text, and in several others not so mentioned, careless errors in misspelling inscriptions can be noted; in most cases the badly effaced letters can be plainly seen under the corrections, but in the portraits of Gondy and de Netz, impressions bearing the misspellings were actually issued before the mistakes were observed and corrected. Similar carelessness is displayed in engraving the artists' names, e.g. on the portrait of Philippe II, upside down on the top of the plate instead of right way up on the bottom, and I think, therefore, that one can very fairly assume that these rare deviations from the rule of arithmetical progression are due to carelessness and not to intention.

Apart from these exceptions, the establishment of this rule of progression of watermarked papers allows one not only, in some cases, to determine the state but also, in normal cases, to estimate the earliness of an impression in that state. Thus, in the case of Andilly, as the impressions of the third state bear watermarks 0 & 2, 3 & 4, 5 & 6, 7 & 8, 11 & 12 and thick papers with a single watermark in the centre, we may assume that those bearing the watermarks 0 & 2 were the earliest printings of this state, and those bearing 11 & 12 and the thick papers with a single watermark, the last. Just as the watermarks 1 & 1 are the very earliest impressions, so those on thick paper with a single watermark in the centre are invariably the latest. One meets occasionally with impressions on very thin paper with no watermarks and, more rarely, on thick paper without a watermark.

Where an asterisk appears after the description of a state it indicates that the state, though reported on reliable authority, had not been seen by either Petitjean or myself.

As regards the known collections of Morin's portraits, full collections are extremely rare and, as far as my information goes, do not exceed five—these being at Paris, London, Cambridge, Boston (Mass. U.S.A.), and, finally, my own. The Paris collection at the Bibliothèque Nationale is possibly the finest, but even that does not

contain all the earliest states; that of the British Museum in London, being laid down in a bound volume, many of the watermarks could not be determined, but, generally speaking, the later states considerably outnumber the earlier ones, Petitjean disposed of his own very fine collection, shortly before his death, to Boston, and John Charrington's, not quite so fine, has gone to the Fitzwilliam Museum at Cambridge. My own was about equal to Petitjean's, but the greater part of it had to be left in my French home when the German invasion drove me out of it, and although French friends sent me word that they had taken most of my collections out of the house before the Germans seized it, I shall not be surprised to learn that they have been sent, with many other treasures, to Berlin.

LIST OF THE PORTRAITS

WITH THEIR CORRESPONDING NUMBERS
IN ROBERT-DUMESNIL'S *CATALOGUE*

NOTE ON THE WATERMARKS
ON THE PAPERS UPON WHICH THE PORTRAITS
OF JEAN MORIN ARE PRINTED

The watermarks on the papers upon which the portraits of Jean Morin are printed are found either at the top and at the bottom, or in the centre of the sheet.

I

In the first case, there are nearly always two different watermarks. For example, the watermark no. 3 is seen always on the same sheet as no. 4—one at the top and the other at the bottom of the sheet. The same in the cases of watermarks 5 & 6, 7 & 8, 7 bis & 8, 9 & 10, 11 & 12, 13 & 14, 15 & 16, 17 & 18—one meets them always together, two by two.

Exceptionally, watermark no. 1 always appears by itself, but is repeated twice—once at the top and once at the bottom of the sheet.

Equally by exception, watermark no. 2 is always alone, and one sees it only once, either at the top or at the bottom of the sheet. In the text of the work this paper is indicated by the abbreviation WM 0 & 2.

Finally, on papers marked with watermarks 9 & 10, one finds also, on the side of the paper, a third watermark.

II

The watermarks on the centre of the sheet one finds almost invariably on rather thick paper and, in consequence, they are often difficult to recognize.

III

There exist, also, other papers, without any watermarks. These, as a rule, are of the same quality as those of the first series and are sufficiently thin to put the absence of watermarks beyond question.

Sheets I and II contain nearly all the watermarks that one meets at the tops and bottoms of the sheets. Sheet III contains a certain number of those one finds in the centre of a sheet. Watermarks nos. 14 and 26 are incomplete.

The watermarks illustrated on Sheet I are about actual size, those on Sheets II and III are reduced to about 9/10ths of actual size.

SOME OBSERVATIONS ON THE VALUATION OF MORIN'S WATERMARKED PAPERS

I do not know whether there is an accepted absolute definition of the qualification for a new 'state', but such authorities whose remarks on the subject I have read seem to be in general agreement that changes that constitute new states take place in either (*a*) the inscription, or (*b*) the work. With such a definition I am in agreement as, to my mind, there should be some *material* alteration in detail in either the one or the other as justification. It would seem, however, when one comes to consider the recognized states of some of the Masters, that the definition can be so loose that it would seem to include any mark on a plate which is reproduced in printing and, in enumerating the states of Jean Morin I have been puzzled as to how one can adequately assess the valuation of his watermarked papers. They are his method of indicating a different 'tirage', or a printing of a new set of impressions, and they are invariable.

Robert Nanteuil's methods, on the other hand, varied considerably. For instance, in the case of his portrait of La Vrilliere, the earliest impressions bear the date followed by a 'dot', the next have a 'crochet' added, the next an added comma and the last a second comma. *There is no alteration to either the inscription or the work* in these successive tirages.

In the case of his Boucherat, the second tirage is differentiated by an 'A' faintly scratched on the bottom margin, and in the case of his Louvois, the letters A to E are scratched on the oval, followed by from one to five 'dots', giving in all, about thirty tirages, of which seventeen have been seen, *but it is only in the last that any change in work or inscription appears*.

Nevertheless, in Nanteuil's case, in these and all similar instances both Robert-Dumesnil and Petitjean recognize these 'tirage indications' as separate states, but in Morin's case Petitjean's original notes left them merely as tirages and the point about their valuation did not arise until some time after his death. Since the two normal

states of Louvois, for instance, are raised to a known seventeen, and a possible thirty, states by the inclusion of the tirage indications, it is obvious that some equivalent valuations must be placed on those of Morin—but in his case these are not scratches on the plates but watermarked papers in arithmetical progression.

Let us take Morin's portrait of Verger de Hauranne, R.D. 82, as an example. Of the three known states two tirages of the first have been seen, three of the second and one of the third. If these had been on a portrait of Nanteuil's, it would be credited with six states—as it is we have, in the case of Morin, three states but six tirages.

Again, in the case of J. P. Camus, there were a good many tirages of the first state of which five have been seen, ranging from 1 & 1 to 15 & 16 and it is obvious that the first impressions off a soft copper plate are far more desirable to the connoisseur, and therefore of more value, than those as late as 15 & 16, and, finally, in the case of Henri II, during the forty years of research covered by Petitjean and myself, all the impressions which have passed through our hands have been on papers with the watermarks either 9 & 10 or 17 & 18, but lately a unique impression has come into my possession bearing the exceptionally early watermark of 3 & 4, and if an impression of Nanteuil's can be termed a 'unique first state' simply because it differs in tirage marks from those that follow it, then some equivalent valuation must be placed on Morin's unique Henri II and some distinguishing valuations upon his other watermarked tirage indications, and if, as it would seem, that one is not entitled to distinguish them as different states, then I would suggest the adoption of the method of valuation that I have used in marking my own impressions.

I utilize the ten letters—A to K (omitting I)—to represent the ten groups of watermarks *so far as they are known for each state of a portrait*; for instance, of Anne Herbert, Countess of Carnarvon, there are two known tirages of the first state, 1 & 1 and 0 & 2, and three of the second state, 0 & 2, 5 & 6 and 9 & 10. I therefore mark these impressions of the first state, I, a and I, b, and of the second state, II, a, II, b, and II, c. If, later, a second state is found with watermark 7 & 8, then it would be II, c and the 9 & 10 would be II, d.

As regards the very thin and fine papers without any watermark, we find these very rarely and almost always in first states—as in Conti and Louis XI—where they seem to have been used instead of

WM 1 & 1; therefore, in cases where they are found among other tirages of a state I place them before 0 & 2.

I think it will be agreed that some system of valuation is needed, and the method I suggest is preferable to the more cumbersome one of calling the impressions of a state 'earliest', 'second earliest,' 'latest', etc.

CATALOGUE

1 ANNE OF AUSTRIA

<div style="text-align: right">R.D. 40</div>

HALF LENGTH, slightly turned to the right, she is looking a little to the left, in an octagonal border, resting on a field of horizontal lines. Dressed as a widow with mob cap and black veil. Chemisette and collarette of white lawn.

In the groove of the border:

<div style="text-align: center">ANNE.D'AUSTRICHE.ROYNE.REGENTE.DE.
FRANCE.ET.DE.NAVARRE.&.</div>

At the bottom of the plate, on the left and on the right:

Ph. Champigne *pinx* I Morin *scul cum priu Regis*

I. Before the retouching. In particular, the elongated triangle, formed by the chemisette on the part above the right arm, is shaded by long parallel lines, *which are not yet crossed by any little cross-hatchings.* Watermarks 1 & 1. (Paris, Cambridge, Mr M. Hornibrook.)

II. After extra work by the burin on the chemisette, the dress and the face. *In particular, in the left half of the triangle formed by the chemissette, on the part above the right arm, the long parallel lines are now crossed by very numerous little cross-hatchings, almost vertical.* The diagram indicates approximately the position of these cross-hatchings characteristic of the second state. Oblique cross lines have been added to various parts of

the dress, notably along the border, opposite the word NAVARRE and in the shade projected by the right arm on the breast. Finally, one sees, upon the face, between the right eye and the head-dress, some very small oblique cross-hatchings. Papers with watermarks 0 & 2, 7 & 8, and thick paper with a single watermark in the centre of the sheet. (Paris, etc.)

III. The plate, reduced to an oval of 165 × 128 mm., is printed in a passe-partout composed of an oval border resting on a console.

Each angle is ornamented by a rose. On the face of the console is the inscription: ANNE D'AUTRICHE (1). (Paris.)

One also meets with impressions printed in a passe-partout composed of an oval border resting on a pedestal, with a white tablet and without roses in the corners.

(1) NOTE. In this state, this portrait illustrates a collection, published in Paris by Leroy, in 1788, intitled *Les Illustres Modernes, ou Tableau de la vie privée des principaux personnages des deux sexes qui ont acquis de la célébrité en Europe, depuis la renaissance des Lettres.* One finds thirteen plates of J. Morin, cut to an oval and printed in various passe-partouts. They are the following:

1. Reduced to an oval of about 167 × 130 mm., printed in a passe-partout composed of an oval border, posed on a console bearing trophies on the right and on the left: Duc de Guise, Henri II, Louis XI, Philippe II and Maréchal de Villeroy.

2. Reduced to an oval of about 167 × 128 mm., and printed in a passe-partout composed of an oval border, resting on a console with a rose in each angle: Anne of Austria, as above, Saint Charles Borromeo (turned to the left), Brachet de la Milletière, Jansénius, Michel de Marillac and Richelieu.

3. Reduced to an oval of 150 × 127 mm., and printed in a passe-partout composed of an oval border, resting on a console with ornaments in each angle of the plate: Jérôme Franck.

4. Reduced to an oval of 167 × 130 mm., and printed in a passe-partout composed of an oval border, suspended by a ring above a console: Marguerite Lemon, under the name of Jeanne Grey, and Brachet de la Milletière.

Furthermore, one meets the same portraits printed in several different passe-partouts. Thus, Cardinal de Richelieu is printed in passe-partouts nos. 1 and 4. These same passe-partouts have been utilized for other plates of Morin's which do not appear in the work *Les Illustres Modernes, etc.* We have seen Anne of Austria, comte d'Harcourt, Henri IV, Louis XIII, Charles de Valois, du Verger de Hauranne (no. 21) and the Maréchal de Villeroy, and the names inscribed on the face of the console are frequently incorrect, for example, one finds Anne of Austria and de Valois both bearing the name of Maximilien de Béthune, duc de Sully.

HALF LENGTH, slightly turned to the left, she is looking a little to the right, in an octagonal border, posed on a field of horizontal lines. Dressed in Court widow's mourning, with black cap and veil, collarette of white lace and chemisette of white tulle; collar of pearls round the neck and pearls in the ears.

In the groove of the border is the same inscription as that on the preceding number. At the bottom of the plate, on the left and on the right:

Ph Champaigne *pinx* I Morin *scul et excu cum priu R*
This last letter is on the margin.

I. Before a good deal of work on the hair, the head-dress and the bodice. In particular, on the left side of the print, there are no cross-lines on the hair. Watermarks 1 & 1, 0 & 2. (Paris, etc.)

II. Retouched and, in certain places, reworked with the burin. *On the left side of the print the hair is crossed with several little vertical cross-lines.* The diagram indicates the position of these lines characteristic of the second state. The head-dress, behind the chignon, likewise numerous portions of the bodice and the two sleeves, are strengthened by the addition of third, and in some cases, of fourth lines. Watermarks 3 & 4, 7 & 8, 11 & 12. (Paris, etc.)

III. The plate has been reduced in height and width and the work does not occupy more than 264 × 182 mm. The octagonal border with inscription has been replaced by an oval border of 202 × 151 mm., posed on a console. On the tablet of the console was inscribed MAXIMILIEN DE BÉTHUNE // DUC DE SULLY, which one can still read by transparence through a band of paper stuck over it and bearing the words: ANNE D'AUTRICHE // Femme de Louis XIII // Champagne *Pinx*. Morin *Sculp*. On the bottom margin: A Paris chez Bligny, Lancier du Roy, Md. d'Estampes, Peintre, Doreur et Me. Vitrier, Cour du Manége aux Thuilleries.

3 ARNAULD D'ANDILLY R.D. 42

HALF LENGTH, slightly turned to the right, he is looking full face, in an octagonal border, placed on a field of horizontal lines cut by little cross-hatchings, and framed by a black line.

In the groove of the border:

ROBERT.ARNAVLD.SEIGr.D'ANDILLI.CONer.DV.ROY.

EN.SES.CONSLs.D'ESTAT.ET.PRIVE

At the bottom of the plate, on the left and on the right:

Ph. Champaigne *pinx* I Morin *scul cum priu Reg.*

I. Before a considerable amount of extra work. *In particular, the triangular shadow thrown by the border on the right sleeve stops at the height of the left side of the letter* O *of* ROBERT, *that is to say at 12 mm. above the lower left angle of the border;* among the lines which constitute this shadow, there are as yet no vertical lines. There is no isolated hair upon the right temple. The whole aspect of the impression is silvery and clear, and the background is lightly, almost too slightly, shaded. Watermarks 1 & 1. (Paris, Dutuit, Boston.)

II. The plate has been reworked in several places. *In particular, the very black triangular shadow, thrown by the border upon the right sleeve, extends now as far as the lower left corner of that border;* it is rendered still blacker by the addition of thick vertical lines. *There is still no isolated hair upon the right temple.* The collar has been almost everywhere reworked: the lines have been redrawn, and the shadows strengthened by the addition of little cross-hatchings much blacker than those of the first state. The background, notably much darker, particularly on the left side of the print, has been completely reworked and has assumed a woolly appearance which one finds in no other work of Morin, except in the retouched states of the portrait of Mazarin. Moreover, one can perceive several black smears upon the left side of the print close to the head. Finally, on this background, one sees a scratched line commencing at the left shoulder at 2 mm. above the seam of the sleeve. Watermarks 0 & 2. (Mr M. Hornibrook.) [1]

III. The plate has been reworked a second time. *One sees several isolated hairs upon the right temple.* The hair is much darker and more retouched, cross-lines have been added in several places, notably on the top of the head, to the left of the parting. The flesh has been

[1] It is probable that more than one impression of this second state exists, but as it came into my possession only in 1939 when the material for the work was practically completed and the unsettled state of affairs in the world made its comparison with impressions in many of the Continental Museum collections impossible, all I can say is that any other impressions, hitherto regarded as second states, that I have been able to compare it with are all third states.

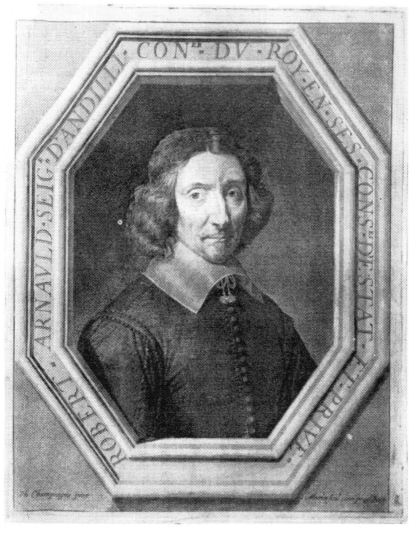

No. 3, State II, a ARNAULD D'ANDILLY

retouched in several places, notably in the shaded parts. On the right side of the print the shadow below the collar is strengthened still more by the addition of thick horizontal lines. The whole of the coat has had its lines reworked and, almost everywhere, new lines, horizontal or slighly oblique, generally very thick, have been added, notably on the buttons in front. The background has been again reworked, there are no longer any signs of black smears near to the head on the left side of the print and the shadow on the top and near the head is rendered still blacker by the addition of several large and very black cross-hatchings; to distinguish them it is useful to examine the print by transparence. Watermarks 0 & 2, 3 & 4, 5 & 6, 7 & 8, 11 & 12, and papers with a single watermark in the centre of the sheet. (Paris, etc.)

The retouching of this portrait seems to have been undertaken in order to strengthen the weakness of the background, and this first retouching having upset the balance of the values, it became indispensable to proceed to a general reworking of the plate. Somewhat similar reasons would seem to have suggested the reworking of the portrait of Mazarin, and in both cases the final result has been unsatisfactory, the portraits having lost most of their quality in the process.

4 CHARLES DE VALOIS, DUC D'ANGOULÊME R.D. 81

HALF LENGTH, turned to the right, he is looking full face, in an octagonal border, posed on a field of horizontal lines. Armour, white scarf and blue sash.

In the groove of the border:

CHARLES.DE.VALOIS.DVC.DANGOVLESME.PAIR.DE.
FRANCE.COMTE.DAVVERGNE

The letters G and O of the word DANGOVLESME are interlaced. At the bottom of the plate, on the left and on the right:

Ph. Champaigne *pinx* I. Morin *scul. cum priu Regis*

I. The state described, before the reduction to an oval. Watermarks 1 & 1, 0 & 2, 3 & 4, 7 & 8, 7 bis & 8, 13 & 14. (Paris, etc.)

II. The plate, reduced to an oval, is printed in a passe-partout. (See the note to portrait no. 1.)

WAIST LENGTH, slightly turned to the right, he is looking to the right, in an octagonal border, posed upon a field of horizontal lines. In the groove of the border:

GVIDO.BENTIVOLVS.S.R.E.CARDINALIS.

OBIIT.ANNO.M.DCXLV

At the bottom of the plate, on the left and on the right:

Antoine van Dyck *pinx* // an 1623 I Morin *scul cum priu Reg*

I. Before all letters. (Paris.)

II. The state described, with the inscription in the border and the artists' names. From about the middle of the groove of the border, between the letters I and S of CARDINALIS a strongly marked, slightly oblique, scratched line, about 15 mm. in length, traverses the remainder of the border. Watermarks 0 & 2, 5 & 6, 9 & 10, and thin paper without watermark. (Paris, etc.)

III. (See note after preface, p. viii.)

6 PIERRE BERTHIER, ÉVÊQUE DE MONTAUBON R.D. 44

WAISTLENGTH, slightly turned to left, he is looking full face, in a rectangular border, having the effect of a window in stone. Pastoral cross.

On the margin at the bottom, on the left and on the right:

Ph. Champagne *pinxit* J. Morin *sculpsit*

We know of only one state, with the names of the artists on the margin at the bottom. Watermarks 0 & 2, 3 & 4. (Paris, etc.)

Robert-Dumesnil, however, describes two states, the first 'Avant la lettre', 'Before the letter', and the second 'With the artists' names', but we have never seen or heard of an impression 'before all letters', nor have we seen one so described in any Sale Catalogue.

Robert-Dumesnil, most probably, is merely reproducing the indication given by the Catalogue of the Franck Sale (no. 2647), which describes an impression 'Before the letter', but which evidently refers to an ordinary impression, with the names of the artists, but, as always, without the name of the personage.

The same explanation most certainly may be given for his first states—'Before the letter'—of the portraits of Borromeo (turned to the right) and of Marguerite Lemon, which both Robert-Dumesnil and the Franck Catalogue (nos. 2650 and 2662) describe in identical

terms. On all these portraits, the name of the personage never appears.

7 ST CHARLES, CARDINAL BORROMEO R.D. 45

WAIST LENGTH, wearing a biretta, turned to the left, seen in profile, he is looking directly to the left, in an octagonal border, posed upon a field of horizontal lines.

In the groove of the border:

S.CAROLVS.CARDINALIS.BORROMAEVS.ARCHIEP.
MEDIOLANEN.NATVS.1538.OBIIT.1584

The P of ARCHIEP was originally R; the traces of the tail of the R, badly erased, are quite visible. At the bottom of the plate, on the left and on the right:

Ph. Champaigne *pinx* I. Morin *scul cum priu Reg*

A scratched line appears above the left extremity of the left eyebrow; a grey spot, which one perceives with difficulty in the earlier impressions, but which in the later impressions becomes more easily distinguished.

I. Before the retouching and before the additional plate. The margin at the bottom is 11 mm. in height. Watermarks 0 & 2, 5 & 6. (Paris, etc.)

II. The plate is retouched. *Long oblique third lines are added at different parts of the biretta.* The diagram indicates the position and direction of some of these lines characteristic of the second state. The hair is reworked and is blacker and thicker and is crossed everywhere with little cross-hatchings, whereas in the first state there were only a small number and only to the left of the seam of the biretta. Watermarks 3 & 4, 9 & 10. (Paris, etc.)

III. The height of the plate is diminished by 9 mm., the margin at the base being not more than 2 mm. (Paris.)

IV. An additional plate of 70 mm. in height is printed below the principal plate. On the face of the pedestal, which occupies almost

the whole width, is the shield of the personage stamped with the coronet of a marquis and supported by two negroes armed with bows. (Paris.)

V. The plate, cut to an oval, is printed in passe-partout no. 2. (See the note to portrait no. 1.) On the face of the console: St Charles Borromée.

8 ST CHARLES, CARDINAL BORROMEO R.D. 46

TO WAIST, wearing a biretta, turned to the right, seen in profile, he is looking directly to the right, in an oval border, flat and without inscription, posed on a field of horizontal lines, crossed with little cross-hatchings.

Quite at the bottom of the plate, on the left:
Champagne *Pi*. Morin *scul*.
There are numerous scratched lines in the angles of the bottom.

I. Before the two accidental marks described below. Watermarks 3 & 4. (M. Suasso, Mr E. A. Ballard.)

II. Traces of two accidental marks are seen on the upper part of the plate, although they have been as far as possible effaced and the work over them remade, especially upon the border. The first, of which the traces are very distinct upon certain impressions, cuts the lower edge of the border at 7 mm. to the right of the middle of the plate, and passes through the background, the biretta, and the hair, ending on the ear; quite often it is not perceivable except on the border, where the scraping has produced little grey marks and has effaced some points of the burin. The second, which is parallel to the other, cuts the border at 22 mm. to the left of the first: the scraping has caused almost completely the disappearance of the points of the burin along a line of about $1\frac{1}{2}$ mm. in width. The diagram indicates the situation of these two marks *on the border. Before the rebiting of the plate.* The impressions are of average tone, without exaggeration of the blacks. Paper without watermark. (Paris, etc.)

III. The plate has been rebitten, the impressions are much blacker than those of the preceding states, with impasto in the flesh and violent contrasts. Watermarks 9 & 10.

Robert-Dumesnil describes a first state 'Before *the* letter'. We do not think that any such exists. See portrait no. 6.

9 HONORINE GRIMBERGE, COMTESSE DE BOSSU R.D. 55

HALF LENGTH, turned to the right, she is looking full face, in an octagonal border, resting on a field of horizontal lines. Dress décolletée, collar of pearls around the neck, pearls in the ears and a brooch on the breast. Long curls of hair fall on the shoulders on each side of the head.

In the groove of the border:

HONORINE.DE.GRIMBERGHE.COMTESSE.DE.BOSSV.ETC.

At the bottom of the plate, on the right:

I. Morin *scul cum priu Reg*

I. Before the retouching described below. Watermarks 0 & 2. (Paris, etc.)

II. With a little retouching on the left sleeve, near the border, between the lower right corner of the border and a scratched line which traverses it at 35 mm. above. The portion retouched is found towards the middle of a band about 2 mm. wide, limited by two incurved lines almost parallel.

The two diagrams herewith give a reproduction of that band in the first and second states. Watermarks 0 & 2, 5 & 6, 7 & 8, 9 & 10. (Paris, etc.)

10 ARMAND DE BOURBON-CONTI R.D. 47

TO WAIST, turned to the left, he is looking slightly to the right and downwards, in an oval border, flat and without inscription, resting on a console. The border, the console and the background are composed of little cross-hatchings, with some marbling at the bottom of the background. Pastoral cross. On the face of the

console, between two palms knotted together with a ribbon, is the monogram of the personage composed of the letters AB interlaced, surmounted by a coronet with fleurs-de-lis.

On the margin at the bottom, on the right:

Juste *p*. Morin *fe.*

I. Before the names of artists on the margin at the bottom. Papers with watermarks O & 2 and also thin without watermark. (Dutuit, Mr E. A. Ballard, Mr M. Hornibrook.)

II. As described, with the names of artists on the bottom margin. Papers with watermarks 3 & 4, 5 & 6, and also without watermark. (Paris, etc.)

Between the border line of the work and the taller letters J of Juste and M of Morin and *f* of *fe.*, there is exactly 1 mm. All impressions therefore with a lower margin deeper than this, on which one can see no trace of letters, should be considered as first states.

11 THÉOPHILE BRACHET DE LA MILLETIÈRE R.D. 48

WAIST LENGTH, turned to the right, he is looking slightly to the left, in an octagonal border, posed on a field of horizontal lines.

In the groove of the border:

THEOPHILE.BRACHET.Sr.DE.LA.MILLETIERE.CONer.DV.ROY.
EN SES.CONls.DESTAT.ET.PRIVE

It is noted that the engraver of the letters had written originally THEOPHIE; the error was corrected by transforming the letter E into L and adding another E; but the portions of the letter E thus effaced are still clearly visible. At the bottom of the plate, on the left and on the right:

Ph Champaigne *pinx* I Morin *scul cum priu Regis*

I. Before all letters. The two angles on the left of the plate are sharp. Watermarks 1 & 1. (Paris, Boston, Mr M. Hornibrook.)

II. As described. Before various work on the skull-cap, the hair, the flesh and the clothing, notably before the third lines directed obliquely from right to left in descending, which reinforce the shadow thrown by the hair on the collar. The two angles are still sharp. Watermarks 1 & 1. (Paris, Mr M. Hornibrook.)

III. After this extra work. In particular, *third lines descending from right to left reinforce the shadow thrown by the hair on the collar.*

No. 10, State I, a ARMAND DE BOURBON-CONTI

The diagram herewith indicates the position and direction of these lines characteristic of the third and fourth states. Several new cross-lines can be seen on the hair, below the ear, on each side at the height of the eyes; also in the left eye-ball, and finally, on the right cheek near the mouth. The flesh has been touched up below the corner of the left eye, where a little place, very clear in the preceding states, is now denser and tones in better with the rest. *The two angles on the left are still sharp.* Watermarks o & 2. (Amsterdam, Mr M. Hornibrook.)

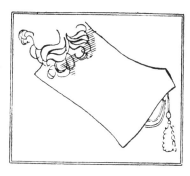

IV. As the preceding, but all the angles are now rounded. Before the plate is rebitten; the impressions are still silvery or of average tone. Watermarks o & 2, 7 & 8. (Paris, etc.)

V. The plate has been rebitten. The impressions, of fresh appearance and printed with great care, are much blacker than in the first state. But, in the flesh especially, they are rather hard on account of the violence of the oppositions. Papers with single watermark in the centre of the sheet. (Boston.)

VI. The plate, reduced to an oval, is printed in passe-partouts nos. 2 and 4. (See the note to portrait no. 1.) On the face of the console, one reads: La Millitière.

12 JEAN PIERRE CAMUS, ÉVÊQUE DE BELLAY R.D. 49

WAIST LENGTH, slightly turned to the left, he is looking full face, in an octagonal border, posed on a field of horizontal lines. Long beard falling on the breast and pastoral cross.

In the groove of the border:

ILLVSTRISSIMO.ECCLESIAE.PRINCIPI.IOANNI.PETRO.
CAMVS.EPISCOPO.DE.BELLEY

At the bottom of the plate, on the left and on the right:

Ph Champaigne *pinx* I Morin *scul cum priu Regis*

I. Before the scratched lines described below. Watermarks 1 & 1, o & 2, 9 & 10, 15 & 16. (Paris, etc.)

II. There are several scratched lines on the listel on the upper part of the plate. There is one below the stop which separates PRINCIPI from IOANNI; another, above the same stop; and also another above the stop which separates IOANNI from PETRO. Thick papers with a single watermark in the centre of the sheet. (Dutuit.)

13 ANNE SOPHIE HERBERT, COMTESSE DE CARNARVON
R.D. 56

HALF LENGTH, turned slightly to the right, she is looking a little towards the left, in an octagonal border, without inscription in the groove, and posed on a field of horizontal lines. Dress very décolletée, with a collar of pearls around the neck; two pearls in the left ear; only one pearl visible in the right ear; a brooch on the breast and jewellery on each arm, a little below the shoulder. Long curls of hair fall, on each side, on the shoulders.

At the bottom of the plate, on the left and on the right:

Ant van Dyck *pinx* I Morin *scul cum priu Reg*

I. As described, with the names of artists. Before retouching. In particular, before the longitudinal fold, formed by some thick and very black lines, which one sees later on the left shoulder, standing out on the light part of the bodice. Watermarks 1 & 1, 0 & 2. (Paris, Dutuit, Boston, Mr M. Hornibrook.)

II. Likewise with the names of the artists. The plate is retouched. *On the left shoulder, the upper part of the light portion of the bodice is now traversed by a longitudinal fold, about 25 mm. in height, formed by several thick and very black lines*, slightly incurved, descending from left to right and inclining a little from the vertical. A little lower down, at the height of the jewel composed of four pearls, one now sees four parallel lines, which did not exist in the first state. The diagram herewith indicates the position and direction of these two groups of lines characteristic of the second state, which stand out clearly on the light material of the bodice. Doubtless on account of some slight accident which has happened to the plate, a portion of its surface, about 9 × 6 mm., immediately below the left breast and quite close to the lower right angle of the octagon, has been clumsily regraved. The pearls of the collar, especially on the left, are more distinctly separated from each other and rather more

shaded. The shadow thrown on the hair, on the right side of the plate, by the left side of the face and neck, has been considerably strengthened by cross-lines all along the contour of the face and notably in the angle formed by the chin and the neck. There is a certain amount of new work on the hair. The flesh of the face has been reworked, notably the eyebrows, the eyes, the nostrils, the mouth, and all the shaded parts of the face, the neck and the breasts. Little cross-hatchings, very different to the minute points which make up the original foundation, have been added to the flesh here and there, particularly on the right cheek. The lines of the face and chin are deeper: a wrinkle is now quite visible to the left of the right nostril, which did not exist in the first state. *Before the scratched lines.* Watermarks o & 2, 5 & 6, 9 & 10. (Paris, etc.)

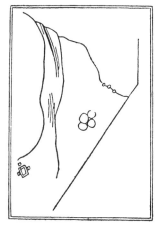

III. Similarly with the names of the artists. On the lower border, at 16 mm. above the lower left angle of the octagon, one sees a vertical and rather thick scratched line about 6 mm. in length. Right at the top of the plate the border is traversed by several oblique scratched lines descending from right to left. Thick papers with a single watermark in the centre of the sheet.

IV. The inscriptions have been effaced and the plate has been reworked.★

V. The plate, reduced to an oval, has been printed in a passe-partout, with the name of Marie-Thérèse d'Autriche. One can read the names of the painter and engraver, and the address of Bligny.★

14 GILBERT DE CHOISEUL DU PLESSIS PRASLIN, ÉVÊQUE DE COMMINGES R.D. 50

WAIST LENGTH, slightly turned to the left, he is looking a little to the right, in an octagonal border, posed on a field of horizontal lines framed by a black line. Pastoral cross.

In the groove of the border:

GILBERTVS.DE.CHOISEVL.CONSILIARIVS.REGIS.INEIVS.
CONSILIIS.ET.EPISCOPVS.COMINGENSIS

At the bottom of the plate, on the left and on the right:
Ph Champaigne *pinx* I Morin *scul priu. Regis*
At the top of the plate, on the right, one can still see traces of the
words 'Ph Champaigne', in letters upside down, which have been
badly erased.

I. As described. The four angles of the plate are sharp. With
the inscriptions and before the retouching. Papers with water-
marks 1 & 1, 0 & 2, and also without watermarks. (Paris, etc.)

II. The four angles of the plate are rounded. Equally before the
retouching and with the inscriptions. Watermarks 9 & 10. (Paris,
etc.)

III. *All the inscriptions have been effaced*, but their traces are still
clearly visible. Retouched. The skull-cap is *everywhere* covered with
oblique cross-lines, there being none on the top of the head in the
first two states. The collar, which was formed of lines spaced
about 1 mm. apart, is now made by lines much stronger and very
close together. One sees the ribbon crossing the bands more dis-
tinctly; the effect, viewed by transparence, is clearer. Finally, in the
background, to the right of the head, the horizontal lines have been
remade and are distinctly blacker. Paper without watermark.
(Paris, etc.)

15 N. CHRYSTIN R.D. 51

WAIST LENGTH, slightly turned to the right, he is looking full face,
in an octagonal border, posed upon a field of horizontal lines and
without inscription in the groove of the border. His head is bare
and he is wrapped in a cloak the tails of which are thrown over his
shoulders.

At the bottom of the plate, on the left and on the right:
Antoine van dyck *pinx* I Morin *scul cum priu Regis*
There is a grey smear upon the eyelid of the left eye.

Only one state is known. Papers with watermarks 0 & 2,
5 & 6, 7 & 8; also without watermarks, and thick with a single
watermark in the centre of the sheet. (Paris, etc.)

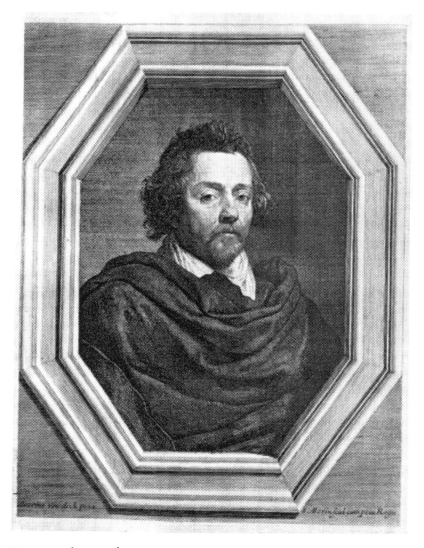

No. 15, only state, b N. CHRYSTIN

WAIST LENGTH, slightly turned to the left, he is looking full face, in an octagonal border, flat and without inscription, reposing on a console. He is clothed in a mantle thrown over a buttoned corselet, with a ruff around his neck. The console and the outer background are cut with irregular lines imitating the veins of marble.

On the face of the console, in large round-hand letters:

<div align="center">Hierosme Francque Peintre du Roy</div>

Below, to the left and the right, in smaller letters:

Francque *Pin.* Morin *scul.*

I. Before all letters. The angles of the plate are sharp. Watermarks 3 & 4. (Paris, Dutuit.)

II. The state described, with the inscriptions above. The angles are rounded. Papers with watermarks 3 & 4, 7 & 8, 13 & 14, and thick with a single watermark in the centre of the sheet. (Paris, etc.)

III. The plate, reduced to an oval, is printed in passe-partout no. 3. (See the note to portrait no. 1.) On the face of the console, one reads: JEROME FRANK.

WAIST LENGTH, turned to the right, he is looking full face, in an octagonal border, resting on a field of horizontal lines. Lace collar, armour, and a scarf around the left arm. A lock of hair, tied with a black ribbon, falls on the shoulder.

In the groove of the border:

<div align="center">FRANCOIS.POTIE.MARQVIS.DE.GESVRES.

ET.MARESCHAL.DE.CAMP</div>

The letter L of MARESCHAL was originally an E, the traces of the effaced lines are still quite visible. At the bottom of the plate, on the left and on the right:

P. Champaigne *pinx* I Morin *scul cum priu Regis*

I. Before the scraping of the light spot on the right arm and before any retouching. Watermarks, if any, are unknown. (Dresden.)

II. On the middle of the right arm, to the right of the line of rivets, a light space or spot, longitudinal, and about $1\frac{1}{2}$ mm. in size,

has been obtained by scraping away some of the lines; it is completely white, but the scraped lines are still more or less observable on certain impressions. In general the traces of the scraping are very visible. *Before the oblique cross-lines on the scarf on the left arm.* Watermarks 0 & 2. (Paris, Boston, Cambridge, Mr M. Hornibrook.)

III. The scarf on the left arm is retouched. The lower part, for a third of the total height, is now crossed by rather more than twenty cross-lines regularly spaced, descending from right to left. The diagram herewith indicates the position and direction of these lines characteristic of the third state. The plate has not yet been rebitten and the impressions, of average tone, are still harmonious. Watermarks 0 & 2, 5 & 6, 9 & 10. (Paris, etc.)

IV. The plate has been rebitten. The impressions, very well printed and blacker than in the earlier states, have a brilliant appearance; but the violence of the oppositions, especially on the flesh, gives them a hard aspect. Thick paper with a single watermark in the centre of the leaf. (Boston.)

18 JEAN FRANÇOIS PAUL DE GONDY R.D. 54

WAIST LENGTH, turned to the right, he is looking full face, in an octagonal border, resting on a field of horizontal lines. Pastoral cross, ornamented with a crucifix.

In the groove of the border:

ILLVSTRISSIMVS.IOAN.PAVL.DE GONDY.ARCH.CORINT.

COAD.PARISIENSIS.&.

At the bottom of the plate, on the left and on the right:

Ph. Champaigne *pinx* I Morin *scul cum priu Regis*

I. The name of the personage, in the inscription on the border, is, in error, misspelt QUODY. The angles of the plate are all sharp. Watermarks 1 & 1. (Dutuit.)

II. The error in spelling is corrected and the name spelt GONDY. Before a certain amount of work, notably there is still a little place absolutely white, above the ring, at the lower left extremity of the ribbon which sustains the pastoral cross. The diagram herewith indicates the position and form of this little white place which one sees only in the first two states. *The angles of the plate are still sharp.* Watermarks 1 & 1. (Paris, etc.)

III. There is no longer the little white place indicated above. *The angles of the plate are still sharp.* Watermarks 0 & 2. (Cambridge.)

IV. The shadows on the hair have been lightly strengthened by the addition of several cross-lines, horizontal and oblique, particularly below the right ear and, on the top of the head, below the skull-cap. Some cross-lines have been added for almost the whole length of the left shoulder. Finally one sees several scratched lines on the collar. The angles of the plate are normally rounded. Papers with watermarks 0 & 2, 9 & 10, 13 & 14, 17 & 18, and thick with a single watermark in the centre of the leaf. (Paris, etc.)

19 HENRI DE LORRAINE, DUC DE GUISE R.D. 57

WAIST LENGTH, turned to the left, he is looking full face, in an octagonal border, resting on a field of horizontal lines. Lace collar, damascened armour and white scarf.

In the groove of the border:

HENRY.DE.LORAINE.DUC.DE.GVISE.PAIR.DE.FRANCE.
ET.COMTE.D'EV.&C.

At the bottom of the plate, on the left and on the right:

I. Citermans *pinx* I Morin *scul. cum priu Regis*

I. Before a stain on the inner background, described below, and before the reduction to an oval. Watermarks 0 & 2, 7 & 8, 9 & 10. (Paris, etc.)

II. Similarly before the reduction to an oval. On the inner background, facing the letter C of FRANCE, one sees a small black stain, at 13 mm. in a horizontal distance from the hair and 27 mm. from the border. Watermarks 9 & 10. (Paris, etc.)

III. The plate, reduced to an oval, is printed in passe-partout

no. 1. (See the note to portrait no. 1.) On the face of the console, one reads: HENRI // DUC DE GUISE. One meets, also, with impressions bearing the name of Maximilien de Béthune, duc de Sully.

20 HENRI DE LORRAINE, COMTE D'HARCOURT R.D. 58

WAIST LENGTH, turned to the right, he is looking full face, in an octagonal border, resting on a field of horizontal lines. Lace collar, armour, white scarf and cross of the Order of the Holy Ghost. A pearl in the right ear and a knot of black ribbon falls on each shoulder.

In the groove of the border:

HENRI.DE.LORRAINE.COMTE.D'HARCOURT.

GRAND.ESCVYER.DE.FRANCE

At the bottom of the plate, on the left and on the right:

Ph Champaigne *pinx* I Morin *scul cum priu Regis*

I. The two upper angles and the lower right angle of the plate are sharp. Watermarks 1 & 1, 0 & 2. (Paris, etc.)

II. All the angles are rounded. Watermarks 9 & 10. (Paris, etc.)

III. The plate, reduced to an oval, is printed in a passe-partout.*

21 JEAN DU VERGER DE HAURANNE R.D. 82

WAIST LENGTH, slightly turned to the left, he is looking a little towards the right, in an oval border, flat and reposing on a console, the whole framed in a rectangle having the effect of stone. He is clad in a surplice.

On the border one reads the inscription:

Mᵣₑ.IEAN.DV.VERGER.DE.HAVRANNE.ABBE.DE.Sᵗ.CIRAN.

DECEDE.LE.XIᵉ.OCTᵉ.M.D.C.X.L.I.I.I.AGE.DE.LXII ans.

The final stop is surmounted by a cross. There is an accent aigu before the letter E of AGE. On the face of the console:

l'Humilité profonde & la haute Science
Firent en ce grand Homme vne Sainte alliance
Il mesprisa l'Honneur, les biens et les Plaisirs
Il vit comme vn neant ce que le Monde enserre
Et son Coeur pour objet de ses nobles desirs
N'eut que Dieu dans le Ciel, & l'Eglise en la terre.

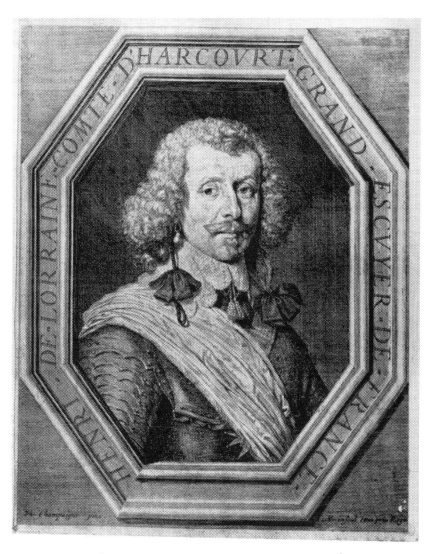

No. 20, State I, b HENRI DE LORRAINE, COMTE D'HARCOURT

At the bottom of the plate, on the left and on the right:

P. Champaigne *Pin.* Morin *scul. Cum Priuil. Regis*

I. Before certain work, notably before the marbling of the frame-work. The upper angles and the lower right angle of the plate are sharp. The left bottom angle is irregular, as if the corner of the plate had been broken. Watermarks 0 & 2, 3 & 4. (Paris, Dutuit.)

II. *The border, the console and the outer framework* are cut with irregular lines imitating the veining of marble. On the inner background thick diagonal cross-lines have been added on the left and above the head; the angle between the border and the left shoulder is strongly shaded at the bottom. Other cross-lines reinforce a large number of folds of the clothing on the left side of the personage. The flesh has been completely retouched and, at least in good impressions, is darker than in the first state; the wrinkles on the face are deeper; the beard, the moustache and the hair are equally remade; several cross-lines have been added on the hair. The lower left angle of the plate, which was irregular as if the corner had been broken, is now thoroughly rounded. *Before the scratched lines described in the following states.* Watermarks 3 & 4, 7 & 8, 9 & 10. (Paris, etc.)

III. Like the second state, but with a scratched line which traverses the left part of the border almost horizontally in such a way as to cut the letter E of DE.HA almost in its middle. Before the scratched line at the bottom of the border. Paper without watermark. (Paris.)

IV. With the preceding scratched line, but with another at the bottom of the border, which traverses between the stop and the number L of DE.LXII. It is quite thick in early impressions, but becomes progressively feebler until it has the appearance of one of the neighbouring marblings. Before the reduction of the plate. Papers without watermarks, with watermarks 13 & 14, and thick with a single watermark in the centre of the sheet. (Paris.)

V. The plate, cut to an oval, is printed in a passe-partout composed of an oval border reposing on a pedestal, without any ornamentation. On the face of the pedestal: L'ABBE DE S^t. CYRAN.

22 JEAN DU VERGER DE HAURANNE R.D. 83

WAIST LENGTH, wearing a surplice, slightly turned to the left, he is looking full face, in an octagonal border, posed on a field of horizontal lines and framed by a black line.

In the groove of the border, in black letters:

EFFIGIES RDI PATRIS D.IOANNIS DV VERGER D'AVRANNE
ABBATIS S.CYRANI.BENE DE ECLESIA.MERITI.M.DC.XXXX.VI.
The word ECLESIA was originally written ECLESIAE; one sees
distinctly still the traces of the letter E badly erased. At the bottom
of the plate, on the left and on the right:
Ph. Champaigne *pinx.* I Morin *Scul. cum priu. Regis*

I. Before the black stain of the third state and before the retouching
of the right eye of the personage of
the second state; the iris is every-
where clear in tone in opposition to
the pupil, which is, with the ex-
ception of the little white triangle,
completely black. The lower angles
of the plate are sharp. Water-
marks 1 & 1, 0 & 2. (Paris, Mr M. Hornibrook.)

II. Similarly before the black stain of the third state: the iris of
the right eye is retouched, the black forming the pupil encroaches
upon the iris on the left side of the print, as shown in the enlarged
diagram above. The angles of the plate are all rounded. Water-
marks 7 bis & 8, and papers with a single watermark in the middle
of the sheet. (Paris, etc.)

III. Towards the middle of the left cheek, about the height of
the mouth, one sees a large oval black stain about 10 × 4 mm.
Papers with a single watermark in the centre of the sheet.

23 JEAN DU VERGER DE HAURANNE R.D. 84

He is represented in the same proportions as in the preceding por-
trait, but in reverse, of a strength of tone much superior, in an oval
without border or inscription or letters, suggesting a piece not quite
finished. It is said to be extremely rare.*

We have never met with an impression of this portrait, and, if it
exists, it is most probably a trial proof.

24 HENRI II R.D. 59

WAIST LENGTH, turned to the right, he is looking full face, in an
octagonal border, flat and without inscription, resting on a console.

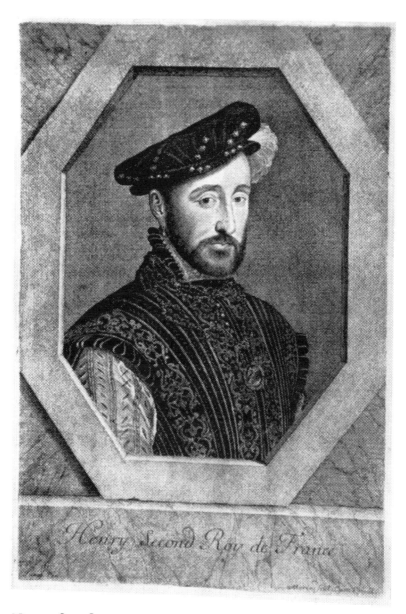

Henry Second Roy de France

No. 24, State I, a HENRI II

He is wearing a velvet cap embellished with precious stones and is clothed in a velvet doublet with slashed sleeves and has the collar of the order of St Michel around his neck. The console and the outer background are cut with irregular lines imitating the veins of marble.

On the face of the console, in large long-hand letters:

Henry Second Roy de France

Below, on the left and on the right, in smaller letters:

Janet *Pin.* Morin *scul. Cum Priuil*

I. The state described. Before the reduction to an oval. Paper with the watermarks 3 & 4. Papers with watermarks 9 & 10, 17 & 18, and without visible watermark. (Paris, etc.)

II. The plate, reduced to an oval, is printed in passe-partout no. 1. (See the note to portrait no. 1.) On the face of the console: HENRI II // ROI DE FRANCE. Of the very many impressions of this portrait that we have seen, only one, which has recently come into our possession, bears these very early watermarks 3 & 4. As these watermarks are found in one or two instances on first states, one would anticipate finding some differences in the work on this impression as compared with those on papers with watermarks as late as 9 & 10 and 17 & 18, but such differences as I have found by comparison with the only other impression available during the war period do not justify me in separating it from others in the existing first state. All one can do is to note that there is a light space on the background, about 5×4 mm., at 90 mm. from the upper left angle of the plate, which is formed of only single lines without the addition of little cross-hatchings, and that in several places on the later impression the lines used for shading have apparently been strengthened. (See remarks on the valuation of these early watermarks on page 9.)

25 HENRI IV R.D. 60

WAIST LENGTH, slightly turned to the right, seen almost full face, he is looking a little to the left, in an octagonal border, flat and without inscription, resting on a console. Damascened armour and white scarf, with cross of the Order of the Holy Ghost partly visible below. The console and the outer background are cut with irregular lines imitating marble.

On the face of the console, in large long-hand letters:

Henry IIII // Roy de France et de Nauarre

Below, on the left and on the right, in smaller letters:

Ferdinand *Pin* Morin *scul*

I. As described, before the scratched lines and before the reduction of the plate to an oval. Watermarks o & 2, 7 bis & 8. (Paris, etc.)

II. As described, and before the reduction of the plate, but with two scratched lines, parallel, spaced about 1½ mm. apart and slightly incurved, which traverse the console almost vertically in passing between the letters *r* and *y* of *Henry* and between the words *France* and *et*. Watermarks 7 bis & 8, 9 & 10. (Paris, etc.)

III. As described, with the two scratched lines, and before the reduction of the plate. Below, between names of painter and engraver, in similar lettering: A Paris chez Bligny Peintre, Doreur Cour du manege aux Thuilleries. Thick paper with lettered watermarks. (Mr M. Hornibrook.)

IV. The plate, most probably reduced to an oval (see portrait no. 31, II) is printed with a framework composed of a border resting on a console and bears the same address. (Camberlyn no. 2218.)*

V. Similarly reduced to an oval, it is reprinted in passepartouts. (See the note to portrait no. 1.)

26 CORNEILLE JANSÉNIUS, ÉVÊQUE D'YPRES R.D. 61

WAIST LENGTH, wearing a biretta, turned to the right, seen in profile, he is looking directly to the right, in an octagonal border, posed on a field of horizontal lines.

In the groove of the border:

CORN.IANSSENIVS.EPISC.IPRENSIS.ET.IN.ACAD.LOVAN.

STEOL.DOCT.PROFES.REGIVS.AET.LIII.IN.VERITATE.

ET.CHARITA^te.

The last A of CHARITA^te, the A of IANSSENIVS and the P of EPISC cover other letters badly effaced. The four last words are in English capitals. At the bottom of the plate, on the right:

I Morin *scul cum priu Reg.*

On the bottom margin: Ce vendent A Paris Chez ledit Morin au fauxbourg St Germain rue du vieux colombier. There is a small oblique line between *A* and *Paris*.

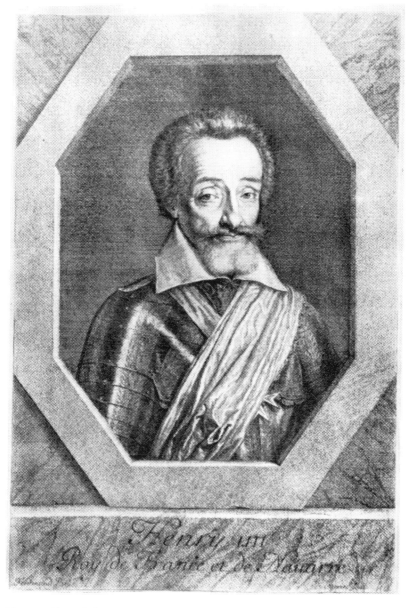

No. 25, State I, b HENRI IV

I. As described, with the address of Morin only on the bottom margin. Before the successive retouches, and before the scratched lines of the fourth and fifth states. *The lower angles of the plate are sharp* and the dimensions of the plate are 303 × 248 mm. Watermarks 0 & 2. (Paris, Boston, Mr M. Hornibrook.)

II. Similarly with the sole address of Morin and before the scratched lines. The biretta is re-touched for the first time. One sees several retouchings with the burin, notably to the right of the point where the middle of the top meets the central seam. Some cross-lines, generally very thick, are added on the left half, but they do not stand out well against the almost uniformly black background of the biretta and, to distinguish them, it is better to regard the print by transparence, placing it before a strong light. The diagram indicates the position and direction of *some* of these lines characteristic of the second state.

The angles of the plate are all rounded and *its dimensions are now* 301 × 246 mm. Watermarks 0 & 2, 3 & 4, 9 & 10. (Paris, etc.)

III. Likewise with the sole address of Morin and before the scratched lines. The biretta is retouched a second time. One can see, notably on the band, cross-lines, usually very thick, have been added. The diagram herewith indicates the position and direction of some of these lines characteristic of the third state. Paper with two watermarks unrecorded on any other portrait of Morin's. (Cambridge, Mr M. Hornibrook.)

IV. Similarly with the sole address of Morin. The biretta is retouched a third time. One can see, on the left half, new work

with the burin and new lines, very thick and very distinct, especially when examined by transparence. The diagram herewith indicates the position and direction of *some* of these lines characteristic of the fourth state. A fine and long scratched line traverses the lower right angle of the border, below the letters SIS.ET and continues across the outer background to meet the border line at 50 mm. above the right angle of the plate. Thick papers with a single watermark in the centre of the sheet.

V. Following the inscription on the margin at the base, one reads: *Et Pr. Chez Basset rue S. Jacques.*★

VI. The plate, reduced to an oval, is printed in passe-partout no. 2. (See the note to portrait no. 1.) On the face of the console: JANSENIUS.

27 MARGUERITE LEMON R.D. 62

HALF LENGTH, completely turned to the right, seen three-quarter face, she is looking full face, in an octagon border, without inscription in the groove, and posed upon a field of horizontal lines. Flowers in her hair and pearls round her neck; the left hand rests on the breast.

At the bottom of the plate, on the left and on the right:

Ant van Dyck *pinx* I Morin *scul cum priu Reg*

The *g* of *Reg* is in the margin.

I. Before the retouch. In particular, quite close to the left lower corner of the border, two little lozenge-shaped places, very light in tone, are shaded only by lines inclined slightly from the horizontal. Another little triangular place, which touches the horizontal part of the border, near to its lower left angle, is completely white. (See the diagram below.) Watermarks 1 & 1. (Paris, Boston, Mr M. Hornibrook.)

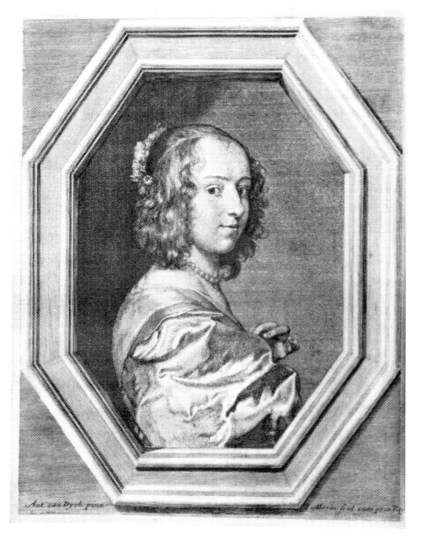

No. 27, State II, b MARGUERITE LEMON

II. The plate is retouched. In particular, the two little lozenge-shaped places, in question above, are now crossed with second lines almost parallel to the lower left side of the border and the little triangular white place is covered with fine lines inclined from the same direction. (See the diagram.) To the right of the lower right corner of the border, some lines have been added and others prolonged as far as the border. To the left of the same corner some long lines descending from right to left have been added.

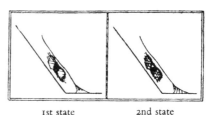

1st state 2nd state

The flesh has been strongly retouched, principally by means of little cross-hatchings, very fine and very short, added on the forehead above the left eye, on all the right cheek, and on the chin, which is better shaped and very well defined. The hair, between the flowers and the parting, is crossed with oblique cross-lines. On the right side of the print, the shade of the cheek on the hair is accentuated by numerous cross-lines, oblique and very close together. *Before the scratched line.* Watermarks 1 & 1, 0 & 2. (Paris, etc.)

III. At the bottom of the plate, the border is traversed, *for almost its entire height*, by a scratched line, descending from left to right at an angle of about 45 deg., which one sees slightly below another scratched line already existing in the two earlier states. *Before the rebiting of the plate.* The impressions are of average tone without the blacks being exaggerated. Papers thin and without watermarks.

IV. The plate has been rebitten. The impressions are hard, much blacker than the first state, with very violent oppositions. Papers with a single watermark in the centre of the sheet.

V. The plate, reduced to an oval, is printed in passe-partout no. 4 and bears the name of JEANNE GRAY, engraved on the face of the console. (See the note to portrait no. 1.)

Robert-Dumesnil describes a first state 'Before *the* letter'—this state does not exist. See portrait no. 6.

WAIST LENGTH, completely turned to the right, seen in profile, he is looking in front of him, in an octagonal border, flat and without inscription, resting on a console. He is wearing his traditional cap, with a hood covering the neck, and a medal of the Virgin on the side. The collar of the Order of Saint Michel, from which is suspended the badge, is thrown over the shoulders. The border, the console, and the outer background are cut with cross-hatchings, and irregular lines imitating the veining of marble.

On the face of the console, in large long-hand letters:

<p align="center">Louis XI^e Roy de France</p>

On the right and below, in smaller letters:

<p align="right">Morin scul Cum Priuil. Re.</p>

I. Before all letters. Thin paper without watermark. (Dutuit.)

II. The state described, with the above inscriptions. Paper with watermarks 3 & 4, without watermark, or thick papers without *visible* watermarks,[1] or with a single watermark in the centre of the sheet. (Paris, etc.)

III. The plate, reduced to an oval, is printed in passe-partout no. 1. (See the note to portrait no. 1.) On the face of the console:

<p align="center">LOUIS XI // ROI DE FRANCE.</p>

29 LOUIS XIII R.D. 64

WAIST LENGTH, slightly turned to the right, he is looking full face, in an octagonal border, resting on a field of horizontal lines. Lace collar, armour decorated with fleurs-de-lis, and a white scarf with the ribbon of the Order of the Holy Ghost below.

In the groove of the border:

<p align="center">LOVIS.XIII.PAR.LA.GRACE.DE.DIEV.TRES.CHRESTIEN.
ROY.DE.FRANCE.ET.DE.NAVARRE.&.</p>

The letters IEV of DIEV cover other letters badly effaced. At the bottom of the plate, on the left and on the right:

Ph Champaigne *pinx* I Morin *scul cum priu Regis*

[1] When the papers are thin there is no difficulty in finding watermarks, if they exist; with the thick papers it is sometimes very difficult to discover them, hence the proviso 'Without *visible* watermarks'. The impression in my possession is the only one I have ever seen of this portrait on thin paper and bearing watermarks; they are 3 & 4 and it is a second state.

I. Before a considerable amount of work with the burin, especially on the ribbon of the Order of the Holy Ghost and on the hair. In particular, that part of the blue ribbon which one sees, between the lace collar and the white scarf, is very clear in tone; the bottom is almost everywhere completely white; one does not yet see any oblique cross-lines descending from left to right and, consequently, parallel to its direction. Watermarks 1 & 1. (Dutuit, Boston, Mr M. Hornibrook.)

II. After a considerable amount of work with the burin on the blue ribbon and on the hair. That portion of the blue ribbon which one sees, between the lace collar and the white scarf, is rendered much deeper by the addition, over all its surface, of cross-lines descending from left to right, and, consequently, parallel to its direction; no longer can one see any portion of it white. The diagram herewith indicates the position and direction of these lines characteristic of the second state. Cross-lines directed in the opposite direction have also been added to all that part of the same ribbon situated below the white scarf. The hair is darkened by cross-lines, especially on each side of the parting, in the shadow thrown by the left cheek and the chin on the left side of the 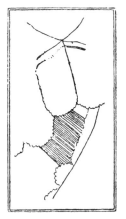 print. The pupil of the right eye is retouched near the corner. *Before the scratched lines.* Watermarks 9 & 10. (Paris, etc.)

III. One sees several scratched lines on the lintel and the border. One should note the following: One scratched line, almost vertical, above the T of TRES, another in face of the word DE on the left side of the impression, and finally two lines, very oblique, above the C of CHRESTIEN. Before the reduction to an oval. Paper with a single watermark in the centre of the sheet.

IV. The plate, reduced to an oval, is printed in passe-partouts. (See the note to portrait no. 1.)*

30 RÉNÉ DE LONGUEIL, MARQUIS DE MAISONS R.D. 65

WAIST LENGTH, slightly turned to the right, he is looking full face, in an octagonal border, resting on a field of horizontal lines, crossed

with little cross-hatchings, and framed with a black line. Robe and ermine.

In the groove of the border:

M^{re}.RENE.DE.LONGVEIL.CHLER.SEIGNEVR.DE.MAISONS.
ET.PRESIDENT.A.MORTIER.&.

After CHLER can be seen a sign of abbreviation. At the bottom of the plate, on the left and on the right:

Ph. Champaigne *pinx* I Morin *scul cum priu Regis*

I. The four angles of the plate are sharp. Watermarks 1 & 1, 0 & 2. (Paris, etc.)

II. The four angles are rounded. Watermarks 9 & 10, and papers with a single watermark in the centre of the sheet.

31 MICHEL DE MARILLAC R.D. 66

WAIST LENGTH, turned to the right, he is looking full face, in an octagonal border, resting on a field of horizontal lines. He is wearing a robe with fur facings, and a skull-cap.

In the groove of the border:

M^{re}.MICHEL.DE.MARILLAC.CON^{er}.DV.ROY.EN.SON.CONSEIL.
DETAT.ET.GARDE.DES.SCEAUX.DE.FRANCE.

At the bottom of the plate, on the left and on the right:

Ph. Champaigne *pinx* I. Morin *scul. cum priu Regis*

I. The state described before the reduction to an oval. Watermarks 1 & 1, 0 & 2, 5 & 6, 7 & 8, and thick paper without *visible* watermarks. (Paris, etc.)

II. The plate, reduced to an oval of 202 × 147 mm., is surrounded by a frame of 264 × 182 mm. consisting of an oval border resting on a console. On the face of the console: MICHEL DE MARILLAC // Garde des sceaux de France Wandick *Pinx* Morin *Sculp.* On the margin at the base: A Paris chez Bligny, Lancier du Roy, Md. des Estampes, Peintre, Doreur et Me. Vitrier, Cour du Manege aux Thuilleries. (Paris.)

III. Reduced to a smaller oval, the plate is printed in passe-partout no. 2. (See the note to portrait no. 1.) On the face of the console: MARILLAC // GARDE DES SCEAUX.

IV. The plate, reduced to an oval, is printed in a different passe-partout, composed principally of a border decorated with garlands of flowers above and a white tablet below. On that tablet one reads: MARILLAC // GARDE DES SCEAUX. On the margin at the bottom on the left: Gravé par Ransonette, G^r. Ord^e. de MONSIEUR.

32 PIERRE MAUGIS R.D. 67

WAIST LENGTH, slightly turned to the right, he is looking full face, in an octagonal border, resting on a field of horizontal lines. He is wearing a mantle, of which one of the ends is thrown over the left shoulder.

In the groove of the border:

> PIERRE.MAVGIS.S^r.DES.GRANGES.CON^{er}.ET.
> MAISTRE.D'HSTEL.DV.ROY.

The letter L of HSTEL was originally an E, of which the superfluous lines have been clumsily effaced. After this word there is a sign in the form of a comma. At the bottom of the plate, on the left and on the right:

Ph Champaigne *pinx* I. Morin *scul cum Priu* // *Regl e s*

Numerous stains cover the last word.

I. Before a considerable amount of work with the burin on the black portions of the clothing and on the hair. Watermarks 0 & 2. (Paris, Boston, Mr M. Hornibrook.)

II. After numerous retouchings and reworking with the burin on the hair and, above all, on the clothing, on which all the folds have been darkened by very deep lines, but frequently these stand out very little on the uni-form black of the folds. In order to distinguish them, especially on strongly inked impressions, one should look at the sheet by trans-parence, placing it before a rather strong light. The diagram herewith indicates, *in several places* (where they are more visible than in others), the position and direction of

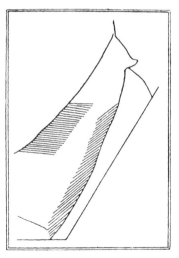

some of these lines characteristic of the second state. *Before the rebiting of the plate.* The impressions are harmonious, without exaggeration of the blacks. Watermarks 9 & 10. (Paris, etc.)

III. The plate has been rebitten. The impressions are hard, lacking in harmony, with the blacks much exaggerated. Paper with a single watermark in the centre of the sheet. (Paris, etc.)

33 CARDINAL MAZARIN R.D. 68

WAIST LENGTH, turned to the right, he is looking full face, in an octagonal border, resting on a field of horizontal lines.

In the groove of the border:

EMINENTISSIMVS.IVLIVS.CARDINALIS.MAZARINIS.&.

At the bottom of the plate, on the left and on the right:

Ph. Champaigne *pinx* I Morin *scul cum priu Regi*

I. Before important new work in several places. One should note particularly the following points: On the inner background there are large stains or smears of irregular shapes. Except above the right ear, the skull-cap is everywhere else formed of single lines. As yet there are no cross-lines descending from left to right on the light front of the cape. One sees no little cross-hatchings on the hair, nor on the moustache, nor on the collar, which, in the shadow thrown on it by the cheek and the chin, is formed of three lines, and by single lines elsewhere. The upper right angle of the plate and the lower left angle are sharp. Watermarks 1 & 1. (Paris, Dutuit, Boston, Cambridge, Mr M. Hornibrook.)

II. With the same inscriptions. The plate is retouched for the first time, and, except in the border and outer background, reworked almost entirely. There are no longer any smeared patches on the inner background, which is now much darker on the right side and has assumed a cottony aspect such as one finds in none other of the works of Morin unless it be in the retouched states of the portrait of Arnauld d'Andilly (portrait no. 3). The skull-cap is *everywhere* crossed with cross-lines descending from left to right. The whole of the light-coloured front of the cape is covered with lines descending from left to right. The moustache, the mouth and the hair are covered almost everywhere with a sowing of little cross-hatchings. The collar is crossed with almost vertical little cross-hatchings over

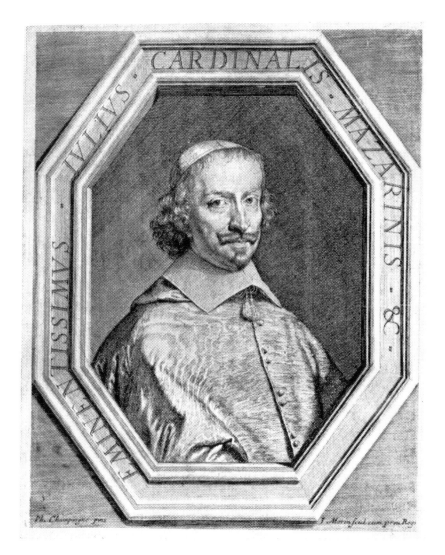

No. 33, State I, a CARDINAL MAZARIN

the whole of its surface, except in the shadow, now much darker, thrown by the cheek and the chin. The upper right and lower left angles are still sharp. *Before the stains described below.* Watermarks 0 & 2. (Paris, etc.)

III. With the same inscriptions. The plate is retouched a second time. On the left side of the print are some stains on the background, below the two curls at the bottom of the hair, which look like a shadow thrown by them. On the opposite side, the angle formed by the chin and the neck-band is nothing more than a black smear. All the shaded parts of the face, the hair and the collar are heavily retouched. The right cheek and the chin are covered with little black points, thick and generally round. All the angles of the plate are rounded. Watermarks 15 & 16.

IV. The inscription around the border is effaced, but its traces are still visible and become more and more distinct with the use of the plate. The name of the engraver, at the bottom on the right, is done away with and the work is carelessly done. There remains nothing more as inscription except: Ph. Champaigne *pinx.* Papers with a single watermark in the centre of the sheet. (Paris.)

V. The name of the painter is also removed and the work is joined up. There is no longer any inscription.★

VI. The name of the engraver is restored at the right on the bottom of the plate, but in this form: I. Morin *scul c. p. R.*

VII. On the front part of the border, one reads the following inscription, in more modern lettering: JULES MAZARIN CARDINAL, né en Italie en 1602, ministre de Fran^e en 1643, mort en 1661. (Duplessis, *Peintre-Graveur,* tome XI.)★

The first state gives the impression of a work to a certain extent unfinished, but very powerful and of the best type. The retouching of the second state unfortunately removed almost all of the qualities of the portrait.

34 JACQUES LE MERCIER R.D. 69

WAIST LENGTH, turned to the right, he is looking full face, in an octagonal border, resting on a field of horizontal lines framed with a black line.

In the groove of the border:

IACQVES.LE.MERCIER.PREMIER.ARCHITECTE.DES.
BASTIMENTS.DV.ROY.ET.DE.LA.ROYNE.REGENTE.

At the bottom of the plate, on the left and on the right:

Ph. Champaigne *pinx*. I Morin *scul cum priu Regis*

I. The lower angles of the plate and the right upper angle are sharp. Watermarks 1 & 1. (Lal. de Betz.)

II. All the angles are rounded. Watermarks 1 & 1, 0 & 2, 3 & 4, 7 & 8. (Paris, etc.)

35 NICHOLAS DE NETZ, ÉVÊQUE D'ORLÉANS R.D. 70

WAIST LENGTH, slightly turned to the left, he is looking full face, in an octagonal border, resting on a field of horizontal lines. Pastoral cross.

In the groove of the border:

NICOLAVS.DE.NETZ.CONSILIARIVS.REGIS.IN.EIVS.
CONSILIIS.ET.EPISCOPVS.AVRELIANENSIS.

At the bottom of the plate, on the left and on the right:

Ph. Champaigne *pinx* I Morin *scul cum priu Regis*

I. With two faults in the inscription on the border. The seventh and eighth words of that inscription being written, in error, CIVS CONSILVS. Watermarks 1 & 1. (Boston, Mr M. Hornibrook.)

II. As described, after the correction in the spelling of the seventh and eighth words of the inscription, which are now written correctly EIVS.CONSILIIS. Before very numerous retouchings of the work. In particular, *the lower branch of the pastoral cross throws no shadow to the left.* Above the letters SI of AVRELIANENSIS there is not, as yet, to the left of the big fold shown in the accompanying diagram, more than a single cross-line which reaches the octagon border; furthermore, in that same place and in the immediate neighbourhood of the border, there are, as yet, no cross-lines descending towards the right. On the right side of the collar, the shadow thrown by the hair on the collar is formed of two cross-lines only. Watermarks 1 & 1, 0 & 2. (Paris, Boston, M. Suasso.)

III. After numerous retouchings. *The lower branch of the pastoral cross throws, on the left, a shadow formed of lines that are parallel to it.* Above the letters SI of AVRELIANENSIS some cross-lines, descending from left to right, come down as far as the octagonal border. The diagram herewith indicates the position and direction of these two groups of lines characteristic of the third state. On the right side of the print, the shadow thrown by the hair on the collar is strengthened by a third set of almost vertical lines. The triangular shadow, which runs along the border opposite the letters OPVS.AVREL, is considerably re-worked and blacker. *Before the rebiting of the plate*; the impressions are soft in tone, without exaggeration of the oppositions and without intensification of the blacks. Water-marks 0 & 2, 7 & 8. (Paris, etc.)

IV. The plate has been rebitten. The impressions, much blacker than in the earlier states, are hard, lacking in harmony and with violent oppositions. Papers with a single watermark in the centre of the sheet.

36 PHILIPPE II, ROI D'ESPAGNE R.D. 71

WAIST LENGTH, slightly turned to the right, he is looking to the right, in an octagonal border, resting on a field of horizontal lines. He is wearing a black doublet bordered with fur and embellished with precious stones, and the collar of the Order of the Golden Fleece.

In the groove of the border:

PHILIPPES.S CECOND.ROY.DES.ESPAGNES.ET.DES.INDES.

The names of the artists are engraved, at the top of the plate, upside down and one reads, on the right, in place of an earlier inscription effaced: Titiani *pinx*, followed by two spaced points, and on the left: I Morin *scul cum priu Reg* At the bottom of the plate, on the

right, one sees traces of an effaced inscription over which the work has been remade.

I. Before the retouching. In particular, along the lower left side of the octagonal border, facing D in DES, there exists a little clear space, shaded simply by lines parallel to the border, not as yet crossed by cross-lines descending from right to left at an angle of about 45 deg. On the breast, in the unicoloured portions of corselet-bodice, there are, as yet, no cross-lines descending from left to right. Watermarks 1 & 1. (Paris, Dutuit, Cambridge, Mr M. Hornibrook.)

II. After a good deal of new work. In particular, *along the lower left side of the octagonal border, in face of* D *in* DES, *there is no longer the little clear space, the lines parallel to the border being now crossed with cross-lines descending from right to left,* as shown in the accompanying diagram, which gives the position and direction of some of the lines characteristic of the second state. On the breast, the unicoloured portions of the corselet-bodice are crossed with cross-lines descending from left to right at an angle of about 45 deg. The right shoulder, to the left of the chain, has been strengthened by a series of cross-lines, very crowded, perpendicular to the line of the shoulder. One must also note the strong retouchings with the burin on the right arm near the border and facing the word ET. *Before the incurved scratched line traversing the lintel of the border,* at the top of the plate. Watermarks 0 & 2. (Paris, Mr M. Hornibrook.)

III. An incurved scratched line, about 12 mm. in length, traverses the border, at the top of the plate, at 28 mm. from the right upper corner of the border. *Before the rebiting of the plate.* The impressions are of average tone, without violent oppositions or exaggeration of the blacks. Watermarks 9 & 10, 13 & 14. (Paris, etc.)

IV. The plate has been rebitten. The impressions, much blacker than in the earlier states, are hard, lacking in harmony, with violent oppositions. Papers with a single watermark in the centre of the sheet.

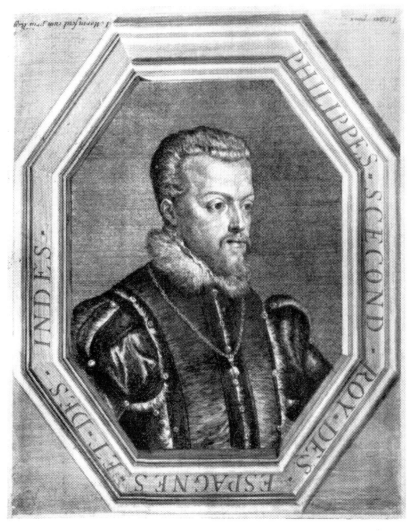

No. 36, State I, a PHILIPPE II, ROI D'ESPAGNE

WAIST LENGTH, slightly turned to the left, he is looking full face, in an octagonal border, posed upon a field of horizontal lines. Cross of the Holy Ghost.

In the groove of the border:

EMINENTISSIMVS.Armandvs IOANNES.DV.PLESSIS.
CARDINALIS.RICHELEVS.&.

The word Armandvs, which was forgotten, has been engraved above the line. At the bottom of the plate, on the left and on the right:

Ph. Champaigne *pinx* I. Morin *scul cum priu Regis*

I. Before the scratched lines and little cross-hatchings of the third and fourth states and *before the two scratched lines in the form of a 'fish-hook'* of the second state. Watermarks 1 & 1. (Paris, London, Cambridge, Mr M. Hornibrook.)

II. On the left side of the collar, where it touches the beard, and about as far from the opening of the collar as is the depth of the opening, one sees *two scratched* lines, descending from the beard into the collar and *forming a 'fish-hook'*. (See the enlarged diagram.) Before the

scratched lines of the third and fourth states and before the little cross-hatchings added to the wing of the nose. Watermarks 0 & 2, 9 & 10. (Paris, etc.)

III. A small scratched line appears on the left side of the collar; it is 3 mm. long and one finds it exactly below the extreme point of the moustache, on the right side of the print. Several little cross-hatchings have been added to the flesh, on a line coming from the tip of the nose to the left ear; these are particularly recognizable on the wing of the nose. Papers with a single watermark in the centre of the sheet. (Paris, etc.)

IV. Another little scratched line, the same size as the preceding, crosses the other at an acute angle. Papers with a single watermark in the centre of the sheet. (Paris, etc.)

V. The plate, cut to an oval, is printed in passe-partout no. 2. (See the note to portrait no. 1.) On the face of the pedestal:

LE CARDINAL // DE RICHELIEU.

One finds also impressions printed in passe-partout no. 4.

38 ST FRANÇOIS DE SALES R.D. 73

WAIST LENGTH, very slightly turned to the left, he is looking a little to the right, in an octagonal border, flat and without inscription, resting on a console. The console and the border are marbled with long irregular lines; the inner background is marbled with veins made of much smaller lines. He is wearing a chasuble with embroidered facings and a pastoral cross.

On the face of the console, one reads the following inscription in large round-hand lettering:

francois de Sales Euesque et Prince de Geneue.

At the bottom of the plate, on the right and in smaller letters:

Morin *Scul Cum Priuil.*

Only one state is known. Papers with watermarks 3 & 4, 9 & 10, and thick papers with single watermarks in the centre of the sheet. (Paris, etc.)

39 OMER TALON R.D. 74

WAIST LENGTH, slightly turned to the right, he is looking full face, in an octagonal border, flat and without inscription, posed on a field of horizontal lines, crossed with little cross-hatchings. The octagonal border is cut with irregular lines imitating the veins of marble.

At the bottom of the work, on the left and on the right:

P. Champaigne *Pin.* Morin *scul. et ex.*

On the margin at the bottom: Audomarus Taloeus, in Supremo Senatu Aduocatus // Catholicus, Christianissimo Regi a Secretioribus Consilijs.

I. Before the inscription on the margin and before certain work on the hair and especially the clothing. In particular, the little fold on the upper left sleeve, that which abuts, at about 5 mm. below the angle of the octagonal border, is marked only by short cross-lines

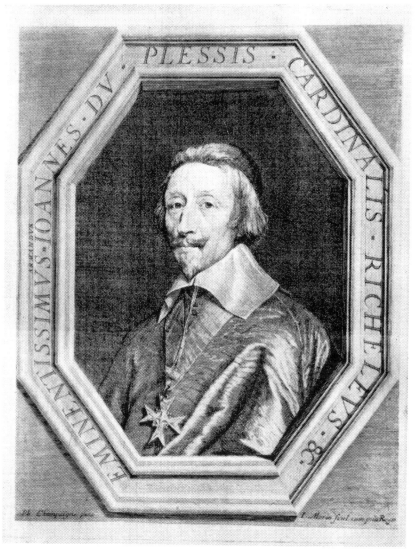

No. 37, State I, a CARDINAL RICHELIEU

almost horizontal and is not very distinct. The shining bands of the *velvet* facings of the robe are almost everywhere made of single lines: there are not yet any cross-lines descending from right to left. Watermarks 3 & 4. (Paris, Boston, Lal. de Betz, Mr M. Hornibrook.)

II. As described, with the inscription on the bottom margin. The little upper fold of the left sleeve is strengthened by several long lines almost parallel to the line of the arm; the diagram herewith indicates the position of these lines, the absence of which, if the impression has no bottom margin, is characteristic of the first state. The velvet facings of the robe are everywhere crossed with short cross-lines descending from right to left. The shadow along the lower left side of the border is accentuated by thick almost vertical cross-lines. The hair, on the right side of the print, is almost everywhere crossed with little hatchings; in the shadiest parts a network of lines descending from right to left and inclined at an angle of about 20 deg. is superimposed on the network of lines inclined at 45 deg. of the first state. The left sleeve, as in the first state, is clear in tone. *It is made, except in the folds, of single lines*; these folds stand out vigorously in black against the background of the robe. Watermarks 0 & 2, 9 & 10, and papers without watermark. (Paris, etc.)

III. The left sleeve, *strengthened everywhere with cross-lines*, is very black and the folds stand out much less distinctly. Thick papers with single watermark in centre of the sheet. (Paris, etc.)

40 DOM JEAN GRÉGOIRE TARRISSE R.D. 75

WAIST LENGTH, turned to the right, he is looking to the right and up, in an octagonal border, flat and without inscription, posed on a console. He is wearing the black robe of his order, his head being covered by the hood. The console and the outer background are cut with lines imitating the veins of marble.

On the face of the console one reads, in large round-hand lettering, this inscription:

R. P. D. Gregorius Tarrisse Superior // General Cong. S. Mauri //
Below, in smaller letters:

Obijt An. 1648 Die. 25. Sept. Ætatis suæ 74.

At the bottom of the plate, on the left and on the right:

F. Donstan *Pin.* Morin *scul. Cum Pri. Re.*

I. The plate has not yet been rebitten. The impressions, par-
ticularly in their flesh tints, are very soft in tone and harmonious.
On a few very early impressions, the very thick lines made by the
burin on the deep shadows, notably those on the wide fold on the
edge of the right shoulder, although almost touching each other,
still leave a considerable number of white spaces between them, and
most of these lines can therefore be distinguished one from the other,
but on later impressions these lines practically coalesce, causing the
shadows generally to have a flat and uniform appearance and, on
the blackest portions, these lines can no longer be distinguished one
from another. Watermarks o & 2, 3 & 4. (Paris, etc.)

II. The plate has been rebitten. The impressions, particularly
in their flesh tints, are hard and lacking in harmony. The deep
lines, remade by the burin, which form the shadows, especially those
on the right shoulder, are much deeper and, on impressions which
have not been washed and pressed, they stand out in relief. In the
same manner, on the blackest portions, the lines can be distinguished
one from the other. Watermarks 9 & 10. (Paris, etc.)

41 MICHEL ʟᴇ TELLIER R.D. 76

WAIST LENGTH, turned to the right, he is looking full face, in an
octagonal border, posed on a field of horizontal lines cut with
little hatchings, and framed with a black line.

In the groove of the border:

M^{re}.MICHEL.LE.THELLIER.CON^{er}.DV.ROY.EN SES.CON^{le}.
SECRET.DES.COMMANDEM^{s}.DE.SAMA^{te}.

At the bottom of the plate, on the left and on the right:

P. Champaigne *pinx* I Morin *scul cum priu Regis*

I. The four angles of the plate are sharp, or nearly sharp. Before
a certain amount of work on the hair. Watermarks 1 & 1, o & 2.
(Paris, etc.)

II. The four angles are distinctly rounded. Several short cross-lines, descending from left to right, are added to the hair, on the right side of the print, opposite the left cheek bone and the middle of the cheek. On the two diagrams herewith one can note the difference between the first and second states, the position and size of the lines descending from left to right. The additional lines being mostly in the shadow of the cheek, they are frequently not easy to distinguish. *Before the rebiting of the plate*: the impressions are of average tone, without violent oppositions. Watermarks 7 & 8. (Paris, etc.)

1st state 2nd state

III. The plate has been rebitten. The impressions are hard, with strong oppositions, the blacks exaggerated and the whole lacking in harmony. Thick papers with a single watermark in the centre.

The Cabinet des Estampes in Paris possesses an unfinished trial proof, before all letters, in which the bands are almost completely white; the mouldings of the border are not shaded; the forehead is unfinished and a certain amount of work on the clothing has still to be done.

42 AUGUSTINE DE THOU R.D. 77

HALFLENGTH, very slightly turned to the left, seen almost full face, he is looking full face, in an oval border, flat and posed on a field of horizontal lines, crossed with vertical and horizontal hatchings. He is clothed in a robe with a fur border and has a biretta on his head.

On the border is the inscription:

MESSIRE AVGVSTIN DE THOV PRESIDENT AV
PARLEMENT . M.D.XL.I.

A few millimetres beyond the final stop of the inscription are four other small stops. At the bottom of the plate, on the left: Morin *Scul.*

I. Before a considerable amount of work on the hair and face. In particular the upper part of the hair, on the left side of the print, has no cross-lines on it. Watermarks ? and ?. (M. Suasso.)

II. After the extra work. *On the left side of the print, the hair is everywhere crossed with cross-lines.* All the right side of the face, which includes the right side of the nose, is lightened, the right eyeball is retouched and the shape of its eyebrow is perceptibly modified. The line of the lips is more strongly marked. Papers with watermarks 0 & 2, 3 & 4, 9 & 10, 15 & 16, papers without watermarks, and thick paper with a single watermark in the centre of the sheet. (Paris, etc.)

43 CHRISTOPHE DE THOU R.D. 78

WAIST LENGTH, slightly turned to the left, he is looking full face, in an oval border, flat and posed on a field of horizontal lines, crossed with vertical and horizontal hatchings. He is wearing a robe with a thick border of fur, and a biretta on his head.

On the border, one reads the inscription:

MESSIRE CHRISTOPHLE DE THOV PREMIER PRESIDENT.
M.D.LXXXII⊗

At the bottom of the plate, on the left:
Morin *Scul.*

Only one state is known. Papers with watermarks 0 & 2, 3 & 4, 9 & 10, and papers without watermarks. (Paris, etc.)

44 JACQUES AUGUSTE DE THOU R.D. 79

WAIST LENGTH, turned to the right, he is looking full face, in an oval border, flat and posed on a field of horizontal lines, crossed with vertical and horizontal hatchings. Head bare, with a large ruff around the neck, he is wearing a robe with fur facings.

On the border, one reads the inscription:

V.ILLVSTR.IACOBVS.AVGVSTVS.THVANVS.IN.SVPREMA.
REGNI.CVRIA PRAESES.M.DC.XVII⊗

At the bottom of the plate, on the left:
Ferdinand *Pin.* // Morin *Scul.*

I. Before a considerable amount of work on the head and hair. In particular, the four large wrinkles on the forehead are not well defined; above the left eyebrow, one cannot distinguish clearly more than two. On the middle of the head, the height of the hair from the base of the forehead is $12\frac{1}{2}$ mm. There are no horizontal cross-lines in the shadow thrown by the nostrils, above the lips. Watermarks 3 & 4. (Paris, etc.)

II. Retouched. The four large wrinkles are strongly marked: above the left eyebrow, one can clearly distinguish three. The flesh has been slightly retouched: the wrinkle at the bottom of the right cheek and that above the left eye are deeper and more marked. The shadow thrown by the nostrils, above the lips, is strengthened by horizontal cross-lines. On the right side of the print the hair has been foreshortened and, here and there removed, it remains a sort of crown; on the opposite side the curls brought on the forehead are thicker and longer; finally the forehead has been heightened at the expense of the hair, by about 2 mm., so that now the height of the hair from the base of the forehead, in the middle of the head, is about $14\frac{1}{2}$ mm. Papers with watermarks 0 & 2, 3 & 4, 9 & 10, and papers without watermarks. (Paris, etc.)

45 JACQUES TUBŒUF R.D. 80

WAIST LENGTH, slightly turned to the right, he is looking full face, in an octagonal border, posed on a field of horizontal lines cut with vertical cross-hatchings, and framed in a black line.

In the groove of the border:

M^{re}.JACQVES.TVBOEVF.CON^{er}.DV.ROY.EN.SES.CON^{ls}.INTEND.
DE.SES.FIN.ET.PRESIDENT.EN.SA.CHAMB.DES.COMPT^{es}.

The stops which follow INTEND and CHAMB are surmounted with a sign of abbreviation. At the bottom of the plate, on the left and on the right:

Ph Champaigne *pinx* I Morin *scul cum priu Reg.*

I. By reason of an accident in the etching, the outer background, in the upper left corner, is traversed diagonally by a series of grey streaks commencing at the angle of the plate. Inside these streaks the horizontal lines are a little greyer than the others and the little vertical cross-hatchings are barely visible. The two upper and the

lower right angles of the plate are sharp. Watermarks 1 & 1, 0 & 2. (Paris, etc.)

II. An endeavour has been made to remove the traces of the accident in the etching by remaking the horizontal lines and little cross-hatchings in the grey streaks on the upper left angle of the plate. But this work of restoration has been rather heavily done, with the result that the lines that were too grey in the first state are too strongly marked in the second. A black smear can be seen at about 20 mm. to the right of the upper left angle and 12 mm. below the border line. *Before the rebiting of the plate.* The impressions are soft in tone without the blacks being too accentuated. All the angles of the plate are rounded. Watermarks 0 & 2, 9 & 10. (Paris, etc.)

III. The plate has been rebitten. The impressions, printed with great care, have a brilliant and black appearance; but they are rather hard on account of the violence of the oppositions. Papers with a single watermark in the centre of the sheet.

46 JEAN BAPTISTE AMIDOR VIGNEROD R.D. 85

THREE-QUARTER LENGTH, standing between a curtain and a table, the right hand resting on a book, turned to the right, he is looking slightly to the left, in a rectangle without border or framework.

At the bottom, on a margin of variable height, one reads the inscription, engraved in large long-hand writing:

Amidor Jean Baptiste de Vignerod // Abbé de Richelieu.

Below, on the left and on the right:

Champaigne *Pin.* Morin *scul. Cum Priuil. Re.*

I. Before all letters, and before work on the curtain above the head, and on the left side of the cloak. The fold in the drapery, near to the angle of the cape on the right, is formed only of horizontal lines, whereas, in the following states, it is covered with cross-lines. The margin at the bottom is 63 mm. in height. (Recorded by Dutuit in the Collection Meaume.)[1]

II. Similarly before all letters and with a lower margin of 63 mm., but after the work described above. Paper with watermarks 3 & 4

[1] This impression, recorded by Dutuit, was not seen by either Petitjean or by me.

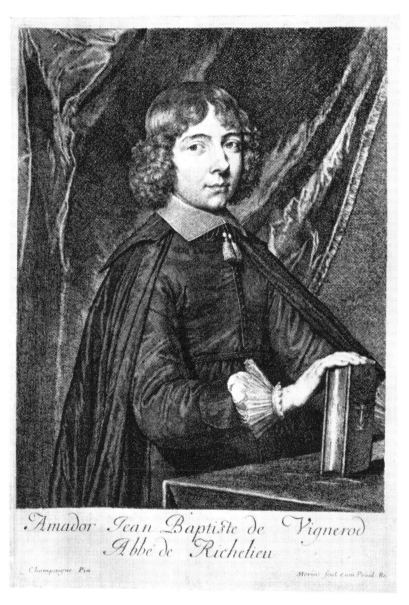

Amador Jean Baptiste de Vignerod
Abbé de Richelieu

Champaigne Pin.

Morin fcul. cum Priui. Re.

No. 46, State III, a JEAN BAPTISTE AMIDOR VIGNEROD

and without watermarks. (Paris, Cambridge, Dutuit, Mr E. A. Ballard, Mr M. Hornibrook.)

III. The state described, with the above inscription of the margin at the base, which is reduced to 38 mm. Papers without watermarks, with watermarks 9 & 10, and thick with a single watermark in the centre of the sheet. (Paris, etc.)

47 FRANÇOIS DE VILLEMONTÉE R.D. 86

WAIST LENGTH, turned to the right, he is looking full face, in an octagonal border, posed on a field of horizontal lines.

In the groove of the border:

F.DE.VILLEMONTEE CHER SEIGr.DE MONTAIGVILLON.ET
VILLENAVXE.CONer.D'ESTAT ORDINAIRE.INTENDt.
EN POICTOV AVNYS.&C.

There is an acute accent before the semifinal E of VILLEMONTEE and a sign of abbreviation above CHER. At the bottom of the plate, on the left and on the right:

Champaigne *pinx* J Morin *Scul.*

I. Before the successive retouches of the second and third states, described below. In particular, on the left sleeve, to the right of the facings, there are, as yet, no cross-lines absolutely horizontal. Watermarks 0 & 2. (Paris, etc.)

II. The plate is retouched a first time. On the left side of the body, a number of lines have been added, or remade, on the shoulder, the robe, the facings and the sleeve. The diagram indicates the position and direction of *some* of the lines characteristic of the second state. They are at times difficult to distinguish, especially upon the shoulder, and it is better to examine the impressions by transparence. Before the retouching of the third state: in particular, to the right of the row of buttons on the robe, there are not as yet any very thick cross-lines parallel to that row of buttons. Watermarks 3 & 4, 5 & 6, 9 & 10. (Paris, etc.)

III. The plate is retouched a second time, particularly on the clothes, on which are numerous reworkings with the burin and additional lines. In particular, on the robe, to the right of the row of buttons, one sees very thick cross-lines parallel to the row of buttons. There is also work on the flesh and hair and one should notice at the corner of the right eye, near the nose, a little place which, completely white in the first two states, is now shaded by little points. Paper without watermarks. (Paris, etc.)

48 NICHOLAS DE NEUFVILLE, MARQUIS DE VILLEROY
R.D. 87

WAIST LENGTH, turned to the right, he is looking full face, in an octagonal border, posed upon a field of horizontal lines. Armour and white scarf.

In the groove of the border:

NICOLAS.DE.NEVFVILLE.MARQVIS.DE.VILLEROY.
MARESCHAL.DE.FRANCE.&.

At the bottom of the plate, on the left and on the right:

Ph Champaigne *pinx* I. Morin *scul cum priu Reg.*

On the bottom margin: Ce vendent a Paris au fauxbourg sainct Germain rue du vieux colombier chez led. Morin

I. Before the retouchings described below. Watermarks 0 & 2. (Paris, etc.)

II. Retouched. Particularly on the cuirass. Almost all the dark parts of the cuirass are considerably more worked: there are many retouchings with the burin and addition of lines. In particular, on the right arm, the first shiny place, that on the shoulder, is narrowed in width, on the side of the arm-pit, by oblique lines engraved below the three nails in a triangle; the second shiny place is reduced in height following the lengthening of some of the lines

descending from right to left. The diagram herewith shows the position and direction of the lines so added and extended, which are characteristic of the second state. *The plate has not yet been rebitten*: the impressions are of an average tone, without violent oppositions and without exaggeration in the intensity of the blacks. Watermarks 9 & 10, 13 & 14. (Paris, etc.)

III. The plate has been rebitten and the impressions, printed with much care, have a brilliant appearance; but the blacks are too intense, the oppositions too violent, and the prints hard and deprived of harmony. Before the reduction to an oval. Papers with a single watermark in the centre of the sheet.

IV. The plate, reduced to an oval, has been printed in passepartout no. 1. (See the note to portrait no. 1.) On the face of the console: LE MARECHAL DE VILLEROY. (Paris.)

49 ANTOINE VITRÉ R.D. 88

HALF LENGTH, slightly turned to the right, he is looking full face, behind a stone sill, in a rectangle without border or framework. He is clothed in a long cloak, of which one of the tails is thrown over the shoulder. The fingers of the left hand rest on the sill. One sees on the sill a composing-stick, three type letters and the page of the title of a book.

Below, one reads the inscription, in long-hand letters:

Antonius Vitre;//Regis & Cleri Gallicani Typographus.

At the bottom of the plate, on the left and on the right:

P. Champaigne *Pin.* Morin *scul Cum Pri. Re.*

In the upper right angle: Æt. 60.

I. Before all letters. (Dutuit.) [1]

II. The state described with the above inscriptions. Before considerable work on the hair, notably before the cross-lines, descending from right to left, upon the left ear and on the hair on the same side. Watermarks 0 & 2, 3 & 4. (Paris, etc.)

[1] In addition to the impression before all letters in the Dutuit collection, I saw in the sale of the Hutton collection at Sothebys on 6 February 1928 a similar impression, which was bought by McDonald on commission from America. I have not been able to trace this impression further. The Catalogue number was 107.

III. After this work. The left ear and the hair on the same side are crossed with cross-lines directed from right to left in descending, which are more visible as the plate becomes worn. The diagram indicates the position and the direction of these lines characteristic of the third state. *Before the rebiting of the plate*, which shows signs of being worn. Watermarks 7 & 8, 9 & 10. (Paris, etc.)

IV. The plate has been rebitten. The impressions have a new fresh look and are very black. Papers with a single watermark in the centre of the sheet.

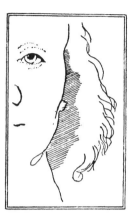